色彩创意
Color Creation

像设计师一样思考色彩
Think about Color As a Designer

叶莉　[英]戴维·布莱姆斯通　刘一玉 著
Ye Li　　　David Bramston　　　Liu Yiyu

中国建筑工业出版社

关于色彩

我想知道，"色彩是什么？"

——毕加索

1919年以来，现代色彩理论的研究主要源自包豪斯学院的约翰内斯·伊顿、保罗·克利、约瑟夫·阿尔伯斯、瓦西里·康定斯基等人的色彩实践与理论。在包豪斯的教学中，为了建立对色彩系统化的认知和理解，色彩被分为色相环、明度、色调等基本要素来进行探讨。通过对色彩的应用实践以及色彩关系的实验来获取通常所说的"色彩感觉"，可以说是包豪斯色彩教学方法的本质。

艺术家和设计师职业不同，但他们在某些方面却十分相似，色彩是他们创作和设计的基本视觉语言，艺术评论家约翰·拉斯金就曾说："在这个世界，所有你眼中看到的一切，不过是那些缤纷色彩的组合。"包豪斯的探索也是为了找寻色彩词汇组合变化中的多样方式及指导性原则，在包豪斯的课程中，建立起了人们对色彩关系的初步认知，明确了色彩丰富而复杂的各种关系，就像那些不同的色调、对比、互补的关系会带来各异的画面效果或是强度不一的视觉冲击。当然，学习伊顿和包豪斯教学中的色彩理论，在实践中的不断探索，都是为了我们能够像伊顿和那些色彩专家一样，轻松地在生活中使用色彩，享受色彩带来的审美愉悦。

约瑟夫·阿尔伯斯发现了人们对色彩的理解与认知的不同："如果一个人说'红色'，50个人脑海中会呈现出50种不同的红色"；埃德加·德加认为黄色是"可怕的东西"，而文森特·凡·高则认为黄色是"可爱的"，因为它是太阳的色彩；瓦萨

About Color

I want to know one thing. 'What is color?'
—Pablo Picasso

The color theory program taught at the Bauhaus by Johannes Itten, Paul Klee, Josef Albers, and Wassily Kandinsky has essentially been the predominant framework for the understanding of color since 1919. Sensory understanding of color practice and exploring a multitude of color combinations was the essence of the approach conducted by Johannes Itten. Color wheels, tints, and tones often explored on an individual basis through methodical studies aimed to enhance understanding amongst the cohorts under Itten's direction.

Artists and designers are different but share common beliefs. The Bauhaus aimed to bring these practices together so that they could benefit from the varied and compatible approaches within the disciplines. The art critic John Ruskin stated that *'everything that you can see in the world around you presents itself to your eyes only as an arrangement of patches of different colors'.* It was often the creation of patches of color at the Bauhaus program that was used to elicit an initial understanding of contrasts and color relationships. Tones of color or opposites being placed alongside each other to create a particular visual outcome or statement. Understanding color practice, exploring relationships and directions is of particular importance and something which Itten's own colleagues and successors understood when they adopted more freedom within their own teachings.

Josef Albers observed the difference in the understanding of color and individual perceptions of color: *'If one says red, and there might be fifty people listening, it can be expected that there will be fifty reds in their minds. And one can be sure that all these reds will be very different'.* Edgar Degas refereed to yellow as *'a horrible thing'* , but Vincent Van Gogh regarded yellow as *'lovely'* since it represented the sun. Wassily Kandinsky often

列里·康定斯基经常将色彩与精神意志扯上关系，并用色彩来描绘声音："色之声是如此的明确，很难找到一个人会用低音来表达明亮的黄色，或者用高音来表达深邃的湖泊。"这些联想十分美妙，它们引导着我们去认知色彩的独特魅力以及色彩组合间的繁多变化。

色彩研究的方法是多样的，新的探索一直在挑战和丰富着传统的观点，通过包豪斯教学发展起来的色彩理论是一些普遍和基本的规则，任何规范或原则都需要我们在进一步的探索中不断完善和发展，甚至是对其边界的逾越和突破，意料之外的新原则、新方法即会应运而生。孟菲斯小组的米凯莱·德·路奇设计的海洋灯(1981)、埃托雷·索特萨斯设计的塔希提台灯(1981)和New End茶几(1984)均运用了"超越那个时代"的色彩与材料，这些作品吸引了大众的眼球并在设计界产生了强烈的反响。对于那个时代来说，这些"另类"的创意作品无疑是前卫并极富冲击力的。

正如马克·夏加尔所说："色彩是美和结果的本质。"

connected colors to the soul and referenced color sounds explaining that the *'sound of colors is so definite that it would be hard to find anyone who would express bright yellow with base notes or a dark lake with the treble'.* Such associations can be understood or explored with individual colors and multiple variations.

The approach to color investigation can be varied and far-reaching. Familiar boundaries and understandings can be challenged in addition to the actual interaction and practice an individual conducts. The color knowledge platform developed through the Bauhaus teachings remains relevant to familiar conditions. However, the same findings can be intentionally disrupted and can be intentionally adjusted to create variants and unexpected differences if creative limits are overturned or revoked. The *Oceanic* table lamp (1981) designed by Michele De Lucchi, the *Tahiti* table lamp (1981) and the *New End* table (1984) designed for Ettore Sottsass, all for Memphis Milano, challenged contemporary thinking. Such avant garde works, with their unexpected color and material combinations, were exhilarating. The intention to do things in an alternative fashion instantly created an array of stimulating directions.

Color, as Marc Chagall implied, is intrinsic to beauty and outcome.

目 录

CONTENTS

Hi, Color!

Mystery of Color Wheel!

How to Communicate and Express through Colors?

How to Use the Power of Color in Your Creation?

How to Generate Idea—Color Creation?

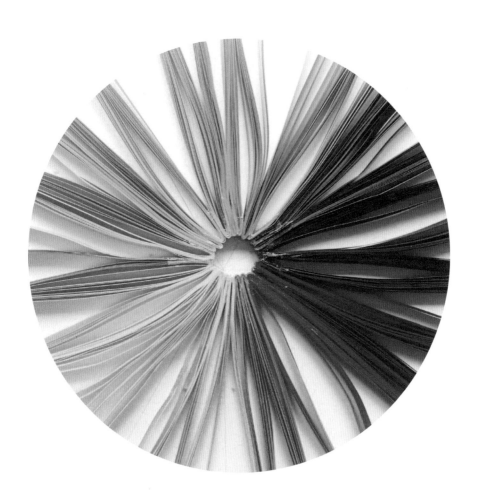

你好，色彩！

Hi, Color！

　　我们首先来做个小实验：在小狗的眼睛里，世界是什么样的？如果狗是色盲，它能分辨出这张照片中的事物吗？或者，它能看到照片中的蓝色吗？网站"犬视觉"曾对人与犬类视觉中的有色光谱进行了比较，从图中可以看到，狗狗眼中的世界可以分辨出特定的蓝色。那么，如果一个人的眼睛，因为缺乏某些色彩辨别微粒（光线感受器）而不能辨别出特定的波长，这就是我们所说的色盲。实际上，色盲还是可以分辨出一些颜色的，红绿色盲的人可以分辨黄色和蓝色。不过，红色在他们看来更像是灰色或棕色。

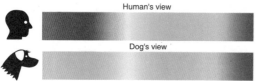

Human's view

Dog's view

　　还有一个关于蓝色的问题："什么是蓝色？"你头脑中闪现的是海军蓝、天蓝、公主蓝，或是知更鸟蛋般的蓝色……甚至说不上名字的蓝色。可见，在没有某种编码的情况下，尝试传达一种特定的蓝色并非易事。20世纪初，波士顿的艺术学院教授阿尔伯特·孟塞尔开发了一种用数字描述色彩的编码系统，有了这个系统，人们可以准确地表达他们想要的蓝色。现在我们常使用的色彩系统就有：新的孟塞尔色彩系统、潘通色彩系统、TRUEMATCH、CIE系统等。

　　所有艺术家也许都会告诉你色彩是如何的重要，无论是哪种媒介下的艺术形式——数字艺术、摄影艺术……色彩都是其中重要表达手段。色彩不仅具有视觉吸引力，而且具有强烈的感召力，而我们要知道的就是如何才能正确使用它。

❝ *The purest and most thoughtful minds are those which love color the most.*

—John Ruskin

❞

May I let you join in a simple color experiment at first?

There is a need to question what the world looks like in the eyes of a dog?

If dogs are colorblind, from the dog vision, do you think they know about this photo? Could a dog picks BLUE one out?

Dog Vision, a web site devoted to canine color perception, printed this side-by-side comparison of how the two species register the color spectrum.

People missing some of these color-detecting molecules(also known as photoreceptors) won't recognize certain light wavelengths. Such people are called color blind, but they actually can make out some hues. Red-green color blind people can still discern yellow and blue, but items in red will appear grey or brown to them.

There is a further question what Blue is? Robin's egg blue, navy blue, sky blue, princess blue... to try and communicate a specific hue is complex without some sort of coding system. Early in the 1900s, Albert Munsell, a professor at an art school in Boston, developed a color system for numerically describing colors. With a published system, people could be accurate about which blue they were referring to, without 'foolish' and 'misleading' . Munsell's system has been reworked for today's use with the Pantone color system, TRUEMATCH, CIE systems and others.

Any artist will tell you that the use of color is a major component of the design process, regardless of the medium. Digital art and photography are no exceptions. Color can be powerful and evocative, but only if we know how to use it properly.

常见的色彩模式

■ 什么是色彩模式？

　　数字产品和印刷品中使用的色彩模式有很多,位图、灰度、双色调、HSB、RGB、CMYK、Lab、彩色索引、多通道、8位/16位模式等,这些都是比较常用的色彩模式。不同的模式运用了不同的方式和编码系统表达色彩,显示的颜色数目也不同。那么,究竟哪种色彩模式好用呢？这当然要取决于我们所用的工具和媒介。当设计师利用电脑生成数字媒体时,色彩通过加色模式实现,而在手绘创作时,色彩的混合则是通过减色模式呈现。

■ 加色与减色模式

■ 加色原色——RGB

　　加色模式是最基本的色彩模式。每一个使用过显示屏的人都接触过RGB(红、绿、蓝)色彩模式,电脑屏幕上看到的颜色,就是使用RGB加色模式创建的。加色模式的组合可以形成几乎所有你想要的颜色,混合色彩的数量越多就会更亮,并趋向于白色。

　　RGB是我们要了解的第一种色彩模式,是一种加色模式。这个模式描述了有色光是如何结合形成色彩的。想象一下,你在KTV里唱卡拉OK,房间里有可调亮度的红、绿、蓝三种灯。接下来,你可以调节每种灯的明暗,将之混合出不同的颜色,让房间立马酷炫起来!如果你把红灯和绿灯打开,房间会铺满了黄色的影调,而当你再打开蓝灯后,房间就充满了明亮的白色。我们要注意,光的色彩混合和颜料的混合方式完全不一样:把红光、绿光和蓝光加

Red　　　**Green**　　　**Blue**

The Red, Green and Blue Additive Model of Color

Color Systems You Should Know

■ Color Systems: What Is It?

The color of computer display and printing of common mode for design and creation: Bitmap Model, Grey Model, Double Tonal Patterns, HSB mode, RGB mode, CMYK, Lab, Color Index, Multi-channel, and 8/16 Bit Mode…each mode of image description recreates the principle of color and can display different numbers of color. The available color mode system is dependent on the medium with which a designer is working. When a designer utilizes the computer to generate digital media, colors are achieved with the additive color method. When painting and sketching, a designer chooses paints, and mixed colors are achieved through the subtractive color method.

■ Additive and Subtractive Primaries

■ Additive Color—RGB

Anyone with a monitor has probably heard of the RGB (red, green, blue) color model. RGB color mode is the most basic color mode, the RGB color mode uses these base colors to form just about every other color you can imagine as red, green, and blue are additive colors; as more colors are added, the result is lighter and tends to white. If we are working on a computer, the colors we see on the screen are created with light using the additive color method, RGB mode.

Our first example will be the RGB color model. This model, sometimes known as the additive color model, describes how colored light combines to make colors. Imagine you're singing karaoke in a KTV room with dimmable red, green, and blue lamps, and by adjusting the brightness of each you can illuminate the room with any color desired color by mixing their light! If you mix red and green equally, the room would appear yellow, and then as you turn on the blue lamp, the room will become white. Add red, green, and blue (RGB) light to create white light. You add the colors together to get white, so we call these the additive

在一起会形成白光,这种方式我们称之为加色三原色或光的三原色,而红、黄、蓝三色颜料混合则会得出大相径庭的结果。

为什么是红色、绿色和蓝色呢?回想一下物理课上的光谱,或者叫光波频率,它的范围就像彩虹一样依次从红色到蓝紫色。从科学的角度来看,光可以是任意一种单色(单频率的光)的混合物。可实际上,当你混合了红色、绿色和蓝色墨水或油漆却不会产生白色。在我们的视网膜中,有一种叫作锥体的感光细胞,可以探测到光谱中红、绿、蓝区域的光能。因此,对我们的眼睛而言,无法区分在光谱上介于红色和绿色之间的"真实"单色——黄光。但是,从设计的角度来看,能否区分似乎就没有那么重要,因为我们是无法感知这种差别的。如果想得到自己想要的颜色,我们可以利用显示屏、电视或变色LED灯等设备,通过混合不同数量的红、绿、蓝色的光来显示出想要的色彩。请记住,加色三原色通常指的是屏幕上的RGB色彩模式,诸如照相机或扫描仪之类的光捕获设备也是使用这三色传感器来模仿人眼对色彩的识别功能。

■ 减色原色——CMYK

如果你去过印刷厂就会知道由青色(Cyan)、品红(Magenta)、黄色(Yellow)、黑色(Key)组成的CMYK模式,平时我们使用的打印机也是使用品红、黄和青作为原色的减色模式,因此CMYK也会被称为印刷色彩模式,其中K是Key的缩写,是Black的另一个名字,表示黑色。它的原理与RGB完全不同,RGB是一种发光的色彩模式,CMYK是一种依赖于反射的色彩模式,它不使用"加法"混合色彩,而是使用减色方式。

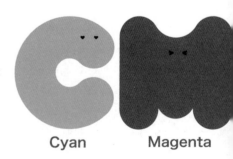

Cyan　　　　Magenta

primaries.

Why are red, green and blue? The way we see color is a bit different from the way we mix paint. Instead of the primary colors of red, blue and yellow, we have two different types of primary colors. Recall a spectrum of light learned from science lessons in school, described as frequencies, ranging from reds through the colors of the rainbow into blues and purples. From a scientific point of view, light can be a mixture of any monochromes, light of a single frequency. Mixing actual red, green, and blue inks or paints does not produce white. However, we have light-sensing cells called cones in the retina of our eyes to detect the amount of light in the red, green, and blue areas of the spectrum. Because of this, 'true' monochromatic yellow light, which lies between red and green on the spectrum, is indistinguishable from a mixture of monochromatic red and green light. From a design point of view, since we cannot perceive the difference, it simply does not matter, and thus we can abstract any color we can see as a mixture of red, green, and blue. So, why our eyes cannot perceive these differences? Due to this fact, many devices, such as monitors, TVs, and color-changing LEDs, reproduce light with red, green, and blue emitting light sources. Colors on the screen are displayed by mixing varying amounts of red, green, and blue light. Keep in mind that the additive primaries typically refer to the RGB on-screen color mode. Similarly, light-capturing devices, such as cameras or scanners, mimic the human eye with sensors of these three colors.

Subtractive Color—CMYK

If you deal with commercial printers, you know about CMYK (Cyan, Magenta, Yellow, Key). Printers and others who adopt modern subtractive color methods and terminology use magenta, yellow, and cyan as subtractive primaries. CMYK is also referred to as printing color mode, which works in an entirely different way than RGB instead of 'additive' types of color, which uses subtractive colors. (i.e. Cyan, Magenta, Yellow, and Key). Key is simply another name for black. CMYK is a kind of color mode that depends on reflection,

ellow　　Black

为什么要用这种方式来描述色彩呢？以印刷品为例，我们要讨论的不是印刷品自己会不会发光，而是那些纸上的油墨所发射出的色彩。如果你喜欢画画或玩过丝网印刷，就会知道印刷中的三原色不再是红色、绿色、蓝色，颜色的多次混合后得到的是越来越接近于黑色的浑浊棕色，因此这种色彩混合方式被称为"减色模式"，也称为CMYK色彩模式。通常，在数字显示器中每种色彩的CMYK的数值比例以0到100之间的数字表示。

■ 如何将RGB转换成CMYK模式？

RGB不仅是显示器中的有色光，屏幕上的网站、在线文档和其他Web图形等的色彩呈现方式也是RGB模式。RGB色彩依赖自然或可发光的光源显示，却不能在纸张上直接呈现。呈现媒介发生转化时，CMYK模式粉墨登场。当两种RGB色彩等量混合时，产生CMYK模式的色彩，即减色三原色。

- 绿色+蓝色=青色／C
- 红色+蓝色=品红色／M
- 红色+绿色=黄色／Y
- +黑色／K

（CMY混合后不能得到黑色，需要另外加入黑色K。）

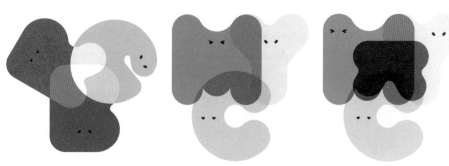

色彩模式：从RGB加色法到CMYK减色法混合方式示意

which is a big difference from RGB: the RGB model is a glowing color scheme.

So why describe colors in any other way? Well, the printing world is an excellent example because of the different color applications. We do not want to describe the light emitted from our print media, and we intend to describe the pigment colors in ink to put on a piece of paper to emit light from that color. Surely that's just red, green, and blue again? If you've printed or painted before, you'll know that's not the case. By adding three primary pigments on a white piece of paper, we tend to get a muddy brown. This color model adds colors to get darker shades, which is sometimes referred to as the subtractive model, but more commonly as four-color process printing, also known as the CMYK model. Typically, you'll see the proportion of each pigment represented digitally as a number between 0 and 100.

■ How RGB Leads to CMYK?

The RGB color model is used on a computer monitor and will view projects while it's still on the screen. RGB is retained for projects designed to stay on-screen (websites, online documents, and other Web graphics, for example). These colors, however, can only be viewed with natural or produced light, such as in the computer monitor and not on a printed page. This is where CMYK comes in. When two RGB colors are mixed equally, they produce the colors of the CMYK model, which are known as subtractive primaries.

• Green and blue create cyan

• Red and blue create magenta

• Red and green create yellow

• Black is added to the model

(Because it cannot be created with the 3 subtractive primaries.)

◼ 为什么要把RGB转换成CMYK模式?

为什么不总是直接用CMYK模式设计作品呢? 当然是可以设定为这种色彩模式,但是使用这种模式的同时我们还必须依赖色卡确定输出后色彩的最终呈现效果,因为显示器是基于RGB模式来显示图像,这就会带来显示器上的色彩与打印或印刷输出后的色彩会呈现细微差别。此外,包括Photoshop在内的一些软件也限制了对CMYK图像的处理,因为软件是基于RGB显示模式而设计的,如果确实需要将图像从CMYK转换成RGB,也不复杂,几乎每个图像编辑软件都有这个选项。在Photoshop中,只需要进行简单的几步操作:图像>模式> CMYK模式。还有,像InDesign和Illustrator(均为Adobe公司软件)这样的设计软件针对的大多是平面设计师,所以通常默认为CMYK模式。平面设计师经常使用Photoshop处理图片,再将这些图片导入专门的排版软件进行版式编排。网页上或某个绘图软件中的CMYK色彩,只是比较接近于印刷效果,也不会完全一致。如果作品需要高质量的印刷效果,如明信片、宣传册等,最好预设时就使用CMYK模式,印刷前再做一个测试校样,以确保输出后的色彩和我们设想的一样。

◼ CMYK印刷的局限性

在印刷中,常见的CMYK组合模式可以产生16000多种色彩,但离人眼所能辨别到的所有色彩还存在一定的差距。由于CMYK颜料的局限性,不能达到很广的色域,所以有很多色彩还是不能完全通过印刷来展现,因此显示器上能看到一些印刷油墨无法精确复制的色彩,比如各种自然的中性色、荧光色或金属色,这些都是印刷油墨在色彩还原的技术层面需要不断突破的方向。随着印刷技术的不断发展,一些技术上的革新已经被普遍使用,例如荧光油墨的出现弥补了原来CMYK无法表现出的荧光色。不知你有没有发现,屏幕上的色彩在不

■ Why Work in RGB and Convert to CMYK?

So why wouldn't we simply work in CMYK while designing a piece destined for print? We certainly can, but we will need to rely on those swatches rather than what we see on the screen because a monitor can only display images in RGB. Furthermore, some programs, including Photoshop, limit what you can do to CMYK images. This barrier is caused by the fact that the program is designed for photography, which uses RGB. If we do need to convert an image from CMYK to RGB for a printer, it is straightforward, and almost every image editing software has this option. In Photoshop, it is as easy as navigating to Image > Mode > CMYK Color. Design programs like InDesign and Illustrator (both Adobe programs as well) default to CMYK because they are optimized for print designers. For these reasons, graphic designers often use Photoshop for photographic elements then import them into a dedicated design program for layouts. When CMYK colors are displayed on the screen, such as on the web or in graphics software, they are just approximations of what the color will look like when printed. There will be differences. If we take our work to a dedicated graphics printer for things like postcards, brochures, etc., they may ask for the image in CMYK. Once we send the file to the printer, work with it and do a test print to ensure that the color is what we expect.

■ Limitations of CMYK Printing

Although the CMYK ink combinations can produce more than 16,000 colors, they cannot produce as many colors as the human eye can see. For general printing, CMYK is a popular choice. However, because of CMYK pigment limitations and cannot reach an extensive color gamut, many colors cannot cover. As a result, you may view colors on your computer monitor that cannot be accurately reproduced using the process inks when printing on paper, such as various natural neutral colors, fluorescent colors, and metallic colors. They can be accurately printed using fluorescent ink, but not using CMYK inks. We will find all the screen colors different on the showing with the different settings or different computer monitors. In some cases, with a company logo where the

同的设置下或在不同的显示器上所显示的效果也是不同的,比如某公司的标志应用,同一种色彩在所有场合下应呈现出完全一致的外观,而CYMK印刷的效果可能只是很相似而已,因此在这种情况下,就必须显示出可分离的单色数值(如借助潘通色卡)来保证色彩使用上的一致性。

■ HSV / HSL色彩模式

注意到图形软件里的HSV色彩设置的选项了吗?它们是用于描述色彩组合的一些基本设置,所有的颜色都可以通过色相、饱和度、明度这三个选项来调节。

与RGB和CMYK不同,HSV基于三个要素:色相、饱和度和明度,依据人类感知色彩的方式来调节色彩。这种色彩设置根据其明暗值(饱和度或灰度)来描述色彩(色相或明度)。在一些软件(如Photoshop)中色彩设置会使用另一种缩写组合HSB,用亮度来替代明度,所以HSV和HSB指的是同一种色彩模式,有时也被称为HSL。HSL也分别代表了色相、饱和度和明度,这三项作为色彩的基本语言,被我们称为"色彩的三要素"。掌握这三个要素是正确观察色彩的关键,如果你想要学习绘画或设计,那么必须要掌握这三个基本要素并逐步了解这些要素间的区别和关系。

■ HEX色彩模式

十六进位码色彩是在动画和网页上经常使用的一种色彩代码。十六进制是一种数字系统,它使用16个唯一的符号代表特定的数值。跟其他任何计算机语言类似,这里面也有个逻辑系统在发挥作用,每次点击后计算机都会识别正确的色彩编码,这就是我们所说的十六进位码。十六进位码色彩由符号#开头,10个数字(0—9)和6个字母(A—F)组成六个字符,构成16,777,216种色彩组合。以靛青#4B0082为例,我们来看一下它的数字组合结构:第一个字符#表明这是"十六进位码的索引数字",三组数字中每两位码就表示一个色彩,如图所示。

4B 00 82
R G B

color must match exactly all other instances of that logo, CYMK inks might give only a similar representation of the color. In this case, a separate solid color ink (a Pantone-specified ink) must be used.

■ HSV / HSL COLOR

You might have noticed HSV (hue, saturation, value) in the color picker of your graphics software. These are all schemes used to describe how various basic colors combine to create the rainbow of colors we see in various media.

Unlike RGB and CMYK, HSV is defined in a way that is similar to how humans perceive color. It's based on three values: hue, saturation, and value. This color space describes colors (hue or tint) in terms of their shade (saturation or amount of grey) and their brightness value. Some color pickers (like the one in Adobe Photoshop) use the acronym HSB, which substitutes the term brightness for value, but HSV and HSB refer to the same color model. HSL (Hue, Saturation, Lightness) is the basic language of color, so we call them 'Three Elements of Color'. Mastering the three elements is the key to observing colors correctly. At the same time, those who want to learn painting and design should have the necessary quality of correct comparison and proper steps.

■ HEX COLOR

Hex Color is a Hexadecimal Color Code that is used on the Flash and website. The hexadecimal number system is a numeral system that uses 16 unique symbols to represent a particular value. Every time we click, a screen will help us to identify the correct color. When computers name a color, there's a logical system at play. Computers use a so-called hexadecimal code. That is 16,777,216 unique combinations of exactly six characters made from ten numerals and six letters after a hash mark #. Those symbols are 0-9 and A-F. Hex numbers represent these combinations with a concise code six numbers are really three sets of pairs. To make sense of Indigo #4B0082, we need to look at its structure.

色彩理论以及如何学习色彩理论

艺术家和设计师们是如何找到完美的色彩搭配的呢？从早期的艺术和设计开始，色彩的使用就遵循了许多规则和原理，被统称为色彩理论。艺术和设计创作一直在遵循并丰富着色彩理论，可以说色彩的理论是艺术和科学的结合，它决定了什么样的色彩搭配起来会赏心悦目，什么样的配色会创造特殊的视觉效果或和谐美感。我们经常使用色相环等色彩理论营造和谐的色彩关系，遵循色彩组合的规则是获取愉悦色彩美感的便捷途径。

■ 色彩理论的积极影响

■ 为什么要学习色彩理论？

对色彩的理解会帮助我们更好地在创意活动中运用色彩，哪些色彩适合我们的需求？哪些色彩放在一起最合适？对这些问题的回答许多都是："看起来这颜色还可以"之类的话语，这多少有些只可意会不可言传的味道。虽然我们的身边充满了色彩，但有时真的很难厘清诸如为什么有些色彩搭配在一起很舒服，而有些却很"别扭"之类的问题，学习了色彩的理论，就可以帮助我们解释这些问题。

学者研究色彩理论一般有两个主要原因：一是用色彩进行沟通，二是掌握并运用色彩。色彩理论作为色彩信息交流的方式，对色彩搭配及其关系的梳理是色彩在视觉与心理层面传达信息的重要基础，准确地运用色彩甚至可以反映出企业的管理思维和运营策略。我们在

HTML Red　　　　Pantone® Red　　　Panto

What Is Color Theory & How Is Color Theory Taught?

Have you ever wondered how designers and artists find the perfect color combination? Since the early days of art and design, the use of color has followed many rules and guidelines, which are collectively known as color theory. Artists and designers use color theory. Color theory is a practical combination of art and science that's used to determine what colors look good together. They use color harmony to create a specific look or feel. We can use a color wheel or other color theories to find color harmonies by using the rules of color combinations. Color combinations determine the relative positions of different colors to find colors that create a pleasing effect.

Positive Aspects of Color Theory

Why Study Color Theory?

If you are involved in the creation or design of visual documents, an understanding of color will help when incorporating it into your designs. Choices regarding color often seem rather mystical, as many seem to base decisions on nothing other than 'it looks right'. Although often told I had an eye for color, the reason why some colors worked together while others did not always intrigue us, and we found the study of color theory fascinating.

Color Theory offers means to communication. During our team teaching, we learned that there were 2 main reasons why scholars investigated color— the first involved the communication of colors, the other involved the application of color. A color scheme is one of the first elements to communicate the message behind the design on both visual and psychological levels. In fact, the color scheme is one of the most important elements. This is because, if used properly, colors can reflect even the overall business marketing strategy. An exploration of teaching practice aims to communicate the theory of Color

rm Red TRUEMATCH ® 6-a

教学活动中围绕伊顿的色彩理论进行了一系列色彩知识的教学设计,如传播色彩理论、学习中国传统色彩观念、与国际学者和设计师间的交流……那么,我们为什么要选择学习伊顿的色彩理论呢?

■ 伊顿色彩理论

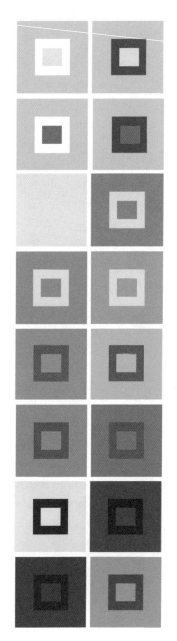

艺术家和设计师们用色彩理论来阐释色彩间的调和方式。虽然在达·芬奇的笔记本上发现了有关色彩的相关理论记载,但大多数学者还是认为艾萨克·牛顿才是色彩理论的开创者。瑞士艺术家约翰内斯·伊顿进一步拓展了牛顿的色彩理论:蓝色的感受、红色的视觉刺激……伊顿对色彩的系统研究始于包豪斯,他从1919年到1922年在包豪斯任教,直到今天,艺术家和设计师们仍在引用和使用他的理论。在他教授的色彩课程中解释了色彩的作用以及是如何起作用的,他的理论不仅说明了色彩及色彩要素间的对比和关系,还揭示了色彩的情感性。伊顿色彩理论和包豪斯教学方式,促进了色彩教学中对色彩理论知识的快速掌握,树立了学生掌握色彩的信心。例如,通过十二色相环(3个原色、3个二次色和6个三次色)可以直观地展示原色概念和饱和度概念。精神分析学说也被融入伊顿的色彩理论中,他是第一位将色彩与情感联系起来的学者,揭示了色彩对我们情绪的影响并探讨了人们感知色彩的方式。

伊顿总结了七种色彩的对比方式:色度对比、明暗对比、面积对比、补色对比、同时对比、色相对比、冷暖对比。伊顿对现代色彩理论最深刻的影响是给予了色彩的温度特性,将色彩赋予了"温暖"和"凉爽"等生理和心理特质,某些颜色是"暖"色,有些颜色是"冷"色,这种说法一直沿用至今。

本书可以作为你的色彩理论入门书,书中介绍的工具和技巧可以帮助"缺乏色彩感觉"的你创造出漂亮的配

theory in the classroom. This involves a series of interviews with practitioners and educators throughout China and the UK. This is likely to focus on the core practices of Itten, although traditional Chinese references should be included. What is the main objective and reasoning behind adopting the Itten Color theory in the classroom?

Itten Color Theory

Artists and designers use color theory to understand the effects of mixing colors. Although the notebooks of Leonardo da Vinci contain writings on color theory, most color theorists point to Isaac Newton as the developer of color theory. Swiss artist Johannes Itten expanded upon the work of Newton and others to develop his theory of color. Feeling blue? Seeing red? Swiss color theorist Johannes Itten (1888–1967) would understand. Johannes Itten's work was first developed at the Bauhaus. Artists and designers continue to refer to and use his work to this day. He taught at the Bauhaus from 1919 until 1922, and he taught one of the fundamental preliminary courses that–among other things–grappled with color theory. He helped explain what colors do and how they do it. Itten's theory takes into account not only a color's contrasting properties but also its emotional ones. Red and blue are altered in expression by different juxtaposed colors. The importance of the Itten color theory and the original Bauhaus teachings also will aim to develop confidence with color amongst the Color Creation cohort. Itten gave us a color sphere comprised of twelve colors (three primary, three secondary, and six tertiary) that shows the relationship among colors, as well as gradations of saturation. The influence of psychoanalysis is apparent in Itten's color theory, as he was one of the first to associate different colors with specific emotions and study the impact of color on our moods. He also studied how individuals perceive color.

Itten taught that there were seven different methods of contrast: contrast of saturation, of light and dark, of extension, complementary contrast, simultaneous contrast, contrast of hue, and contrast between warm and cool colors. Itten's most enduring contribution to modern-day color theory, though, is his characterization of colors in terms of temperature and how they affect us physically and psychologically, and his designations of certain colors as warm and others as cool persist to this day.

Consider this your introductory book to color theory. There are available tools and tips

色效果。继续读下去，了解这些术语、工具和技巧，就会知道怎样在创意中选择出最适合的色彩。

色彩理论的局限

关于色彩理论的5个误区

色彩理论是设计师们首先要掌握的基础知识，它将复杂的色彩现象进行解析，分解成简单的、易掌握的要素与知识点——色相环、原色、色温、色彩调和、色彩心理等。但是，为了让色彩理论易于掌握，总结和梳理理论的过程中简化了某些色彩问题，忽略了一些细节，毕竟这只是些基本原理，它是为了让我们对色彩的整体概念有一个大致、快速的了解。所以，如果想从专业的角度运用色彩，就需要我们更深入地了解色彩原理中那些被简化和忽略的问题。

小提示：

　　对色彩理论的学习也要抱着审视的态度。随着时代的更迭，色彩理论本身没有重大的变化，但对色彩理论传授和实践方法，是否需要与时俱进、及时调整呢？

Tips:

　　An investigation into what might be problematic with traditional Color theory. Since the introduction of the original color theories, there have been considerable changes in practice and process. Although the theory of Color is unlikely to change significantly, does the practice of delivering color theory need to be adjusted for contemporary teaching practice?

☐ 色温

色温表示色彩间相对的冷暖关系。作为色彩原理中最基本的概念，色温通常被分为两组指标或三组指标：暖色和冷色或暖色、冷色和中性色。对色温的理解可以参考摄影光学里的"白平衡"概念。

我们已经知道了，色彩是由光构成的，光的颜色会影响环境中的每个物体的颜色。所以，调节环境中的光的颜色就可以改变所处环境中每个物体的色调。当光的色调统一时，我们的眼睛便可以将这种色调抵消，即使这种光给所有的物品蒙上了黄色或蓝色的色调，我们还是能够辨识出白色的物品。当图片中的白色看起来发蓝时，整个图片都会泛蓝（我们通常将蓝色称之为冷色）；反之，当图片中

out here to help even inartistic of us to create compelling visuals. Read on to learn about the terms, tools, and tips we should know to pick the best colors for our creation.

⬛ Problems with Color Theory

⬛ Five Myths about Fundamental Color Theory

Color theory is one of the first things designers have learned in many fields. It deconstructs the subject of color, turning it into simple rules that can be easily applied in our work. It teaches us about the color wheel, primary colors, color temperature, color harmonies, and the psychology of color.

However, because this basic color theory is so fundamental, it simplifies certain issues and skips over some nuances. After all, these are basic rules that are only supposed to give us a general overview of the concept of color, all in one. However, if you want to be a real professional, we need to understand in more depth.

☐ Color Temperature

Temperature is the relative warmth or coolness of a color. The most basic concept in color theory refers to the fact that hues can generally be separated into two hue groups: 'warm' and 'cool', or three indicators: 'warm' and 'cool' and 'neutral'. This concept is based on something that photographers call white balance.

The colors we see in our environment are made by light. Therefore, the color of this light affects every hue in the scene, changing all the hues consistently. When the tint of the light's color is consistent, our eyes can cancel it out to recognize white as white, even if it looks yellow or blue. When white in the picture looks blue, all the other colors get bluish, too—we call them cool. When white looks yellow, the other colors get yellowish. Cool and warm colors have different meanings in color psychology.

However, how do we identify warm and cool hues? The basic color theory provides

的白色看起来是暖黄色时,其他颜色也相应变成泛黄的暖色。冷色和暖色在色彩心理学上有不同的含义。

如何辨别颜色的冷暖呢?有了色温环,这个问题就变得简单了。它把色彩中的暖色和冷色整齐地分成了两半。虽然这样没有什么本质上的错误,但它却把色温这个问题简单化了。蓝色看上去凉爽、红色看上去温暖,看似简单却很容易导致一种误解,即某些色调本身就是暖色或冷色,就好像温度是某种颜色的固定属性一样,一般规律是:颜色越蓝显得越冷,颜色越黄显得越暖。

那么,问题来了:色温并不是独立存在的!

色彩的冷暖并不是绝对的,它与其周边并置的色彩有着密切的关系,不能只从色相环中选择一种颜色,然后说它是暖的还是冷的。想一想,这个颜色的色温是什么?

如果使用色温环作为参考,你认为它是冷色。现在给它一个参考色:当A绿色旁边是蓝绿色时,绿色看起来就会变暖,因为蓝绿色中含有的蓝色,会使它在绿色旁看起来更冷。然而,当蓝绿色放在蓝色旁边时,蓝绿色就会变暖。A色还是冷色吗?B色在旁边使它看起来会暖了一些吗?如果又添加了C色,那么现在A色彩是什么:暖色、冷色还是中性色?是,也不是,有没有更迷惑?其实,色彩本身没有温度,它是色彩在一定的环境色对比下给人带来的冷暖感受,是人们自发地综合比较了周边复杂色彩因素而得出的一种感觉。

所以一个更准确的色温环应该是这样的。这种方式比较色温时,要记住它们在色相环上的位置,以及它们与黄色或蓝色之间的相对距离。不过,这仍然有缺陷——黄色比橙色是更冷还是更暖?那就只能取决于个人经验了。

us with a simple solution: the color temperature wheel. It's divided neatly in half, separating the colors into warm and cool hues. While there's nothing fundamentally wrong with this picture, it oversimplifies the subject of color temperature. Like this, blue is called cool, and red is called warm. It leads to a misunderstanding that certain hues are warm and cool on their own, as if the temperature were the property of a color. The general rule is: the more bluish the color, the cooler it is, and the more yellowish the color, the warmer it is.

The problem is, the temperature of a color doesn't exist on its own.

The warmth or coolness of a hue is not absolute, but it's strongly related to what colors are around it. We can't just pick one color out of the color wheel and say if it's warm or cool. Think for a moment—what temperature does this color have?

If we used the color temperature wheel as a reference, we called it cool. Now, let's give it a friend: when we paint blue-green next to a green, then the blue-green appears cooler, because it contains some blue. However, blue-green is placed next to blue, then the blue-green is perceived as a warm color. Does this green still look cool to us? We probably noticed that it looks noticeably warmer. Is it warm now? Let's make things even more confusing by adding one more color to the scene. What is color now: warm, cool, or neutral? The truth is: either, and neither. Colors don't have any temperature on their own. The temperature is perceived while comparing them—it's it is a feeling of the comprehensive and complex factors generated in comparison to the others in the scene and the surrounding colors.

Therefore a more accurate color temperature wheel would look like this. When comparing color temperature in this way, keep in mind where they would place on the color wheel, and their relative proximity to yellow or blue. This is still quite arbitrary—is yellow cooler or warmer than orange? The answer will depend on our personal experience.

　　此外，不能只看色温环来选择冷色或暖色，还要注意色彩之间的多重比较关系，就像绿色比蓝色暖，但比黄色冷，等等。毕竟，给它一个淡黄或淡蓝色的色调，就可以改变色温。不信？你可以用任何颜色来试试。这种情况下，经典色温环貌似作用不大。

　　因此，我们一定要确保场景中的所有色彩都具有相同的明度级别，而不是将色相环简单地划分为一半的淡黄或淡蓝色的色调，有目的地创建白平衡可以纠正色温。

Moreover, designers should still not look at this wheel to choose cool and warm tones, but rather to find the relationship between them. For example, green is warmer than blue, but cooler than yellow. After all, all it takes to change the color temperature is to give it a yellowish or bluish tint—and we can do it with any colors, which makes the classic color temperature wheel useless.

Therefore, always make sure that all the colors in the scene have the same tint—either yellowish or bluish instead of limiting yourself to one half of the color wheel. This is enough to create an intentional white balance to correct the color temperature.

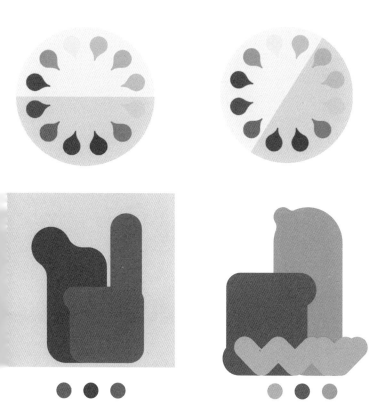

色相环看起来很简单,就像一道完美且充满活力的彩虹。平面设计师、艺术家和画家的理想工具就是有一个像这样的终极调色板。如此完美的工具真实存在吗?前一节曾谈到光的白平衡,我们是在不同的光线条件下观察世界,由于我们的大脑抵消了某些光对色彩变化的影响,所以不太会注意到光源变化的差异,所以我们才能看到恒定的事物。夜晚的街头,透过窗户看到的房间内的灯光或黄或橙,然而,当我们走进房间,却找不到这些橙色物品。这是眼睛的缺陷吗?不,这是大脑的特性。我们的大脑为了识别物体,会忽略某些表象,通过提取物体的共同特征来帮助我们识别。一个绿色的桃子无论它是在阳光下,还是隐藏在阴影中,或是笼罩在阴天柔和的灰色光线里,大脑都会告诉我们它是桃子。只要环境中是受到同一种光的影响,我们的大脑就知道如何"去除"这种影响。

如果你再看看这张照片,就会发现图中这些物体都在泛白,尽管它们的固有色并不是白色。继续观察,你会发现它们是各种各样的白,灰调的白、暖调的白或冷调的白。可能你会说:虽然它们不是真的白色,但是这些颜色已经非常接近白色了。到底是什么原因呢?视觉意义是以视觉信息的形式呈现给人们的,信息与物体的客观色彩特征关系不大,相对于客观的色相和明度,大脑更关心色彩的含义,它是对整体场景做出的解释,并不能像PS软件中的色彩选择器那样精确地识别色彩。

互联网上并非每天都有关于视觉的讨论话题,但有张著名的裙子照片却引发了人们对视觉识别能力的一场网络辩论。同一种色彩怎么可能被看成蓝色和黑色,或者白色和金色呢?人们感知到的色彩也是由他们对光线的

☐ Color Is Relative

The color wheel is simply pleasant to look at—like a perfect, vibrant rainbow. Above all, it is an ultimate palette of color swatches, looks like an ideal tool for a graphic designer, artist and painter. What could be wrong with something amazing? When I talked about white balance, I mentioned this in the previous section. We see the world in diverse light conditions during the day and night, yet it doesn't change much. That's because our brain makes sure to cancel out the effects of the changes, making us see something constant. When walking down the street at night, the rooms behind the windows may look yellow or orange. However, when we enter the room, the orange hue is nowhere to be found. Is it a real bug? It's a feature—our brain simply helps us identify objects by displaying them as the same regardless of how they currently look. A green apple will look green, whether it's illuminated directly by the sun, hidden in shadow, or flooded with the soft, grey light of a cloudy day. As long as the whole environment is subject to the same effects of the light changes, our brain knows how to 'subtract' this effect.

If you look at this photo again. You will see all these objects as white, even though they aren't. Checking these colors, you'll find that they're various shades of greys, warm and cool. You might say, 'Sure, they are not really white, but they are close enough.' Do these colors look almost white to you? What happened here? The meaning is presented to you in the form of visual information, and the information has little to do with the objective color characteristics of the object. Our brain interprets the scene as a whole.It doesn't recognize the colors as Photoshop's Color Picker would. It doesn't care about objective hue or brightness, it cares only what the colors mean.

It's not the Internet that joins together on a vision quest every day, but the Dress—a famous photo that makes people question their visual identity and spark an internet debate. How can the same colors be seen as blue and black, or white and gold? Their perception also informs people's perceived color of lighting. Besides, the image of the dress, taken on a cellphone, contained a lot of uncertainty in terms of lighting conditions. Was it taken inside or outside? This matters because it implies artificial or natural light. Was the dress illuminated from the front or the back? This matters because if it were back-lit, it would be in a shadow,

感知决定的。这条裙子是用手机拍摄的，在光线条件
方面有很多不确定性。是在房间里面拍的还是外面
拍的？这一点很重要，因为它意味着是人造光还是
自然光。是从正面拍的还是从背面拍的？这也很重
要，因为如果它是背光的，它就会处在阴影里。一些
人的大脑消除了假定的过度曝光，将这些颜色解释
为褪色的蓝色和黑色；另一些人则把这些假定的阴
影去掉，把色彩解读为暗白色和金色。不过照片提供
的信息不足以证明哪种说法是正确的，目前发表在
《视觉》杂志上的一项研究得出的基本结论是，这种
分歧可以归结为一点，即每个人感知光线的方式不
同。

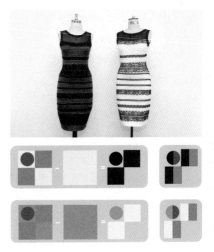

　　一旦被放置在实际场景中，色相环中的色彩可
能就会发生神奇的变化，甚至色彩的温度也会使色
彩本身看起来不一样。暖色似乎会膨胀，而冷色似乎
会收缩，这改变了我们大脑感知大和小的方式。这一
特征使得色彩处理工作变得有点棘手。当然，它并没
有真正改变，只是看起来变了。但对色彩来说，什么
更重要呢？它们本身是什么？还是它们看起来是什
么？在这个色相环中，你可能会看到两种不同深浅的
紫色：左边较暗，右边较亮，就像下面的方块一样。那
么，#E61C17本身是什么样子的呢？实际上，它们是
同一种色彩（#E61C17）。

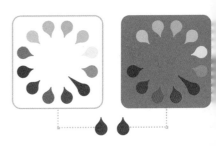

　　可以说，色彩是通过比较而存在的。亮眼的红色在整个彩虹中看起来
非常有侵略性，但如果周围没有蓝色和绿色，红色就会变成一种非常柔和
的色调；同样，紫色在色相环上可能看起来很暗，但是如果有恰当的衬托，
它也会变得耀眼。也就是说，同样是一种色彩，当与之比较的色彩发生了变
化，那么新的关系对原有的色彩就会产生影响。因此，色相环只是一个非常
基础的起点，不应该完全根据色相环上看起来的效果来决定选择什么色
彩。每一个视觉呈现都涉及"图形-背景"的关系。主体（或图形）与其周围的
环境（背景）之间的这种关系将证明其对比的程度。这对我们意味着什么？
这意味着色彩并不是独立存在的。即使你在白色背景上画一个红点，红色

otherwise not. Some people's brains removed the assumed overexposure, interpreting the colors as washed-out blue and black. Other people's brains removed the assumed shadow, interpreting the colors as darkened white and gold. However, there wasn't enough information in the photo to decide which option was right. A study published by the Journal of Vision basically concluded that our differences take all boil down to one thing: how each individual perceives the way light illuminated the dress differently.

Once placed in the scene, the color picked directly from the color wheel may change magically, and even the color temperature makes the color itself look different. Warm colors appear to expand while cool colors appear to contract, changing the way our brain perceives sizes. This feature of our brain makes working with color tricky. Sure, it doesn't really change—it just seems to change. Nevertheless, when it comes to colors, what matters more—what they are, or what they look like? You probably see two different shades of purple in this color wheel: darker on the left and brighter on the right, something like the squares below. So, what does #E61C17 look like on its own? The truth is, it doesn't! They're the same color, #E61C17.

Colors are created by relationships. Bright red can look very aggressive in the company of a whole rainbow, but it can be turned into a quite subdued tone when there are no blues and greens around. Similarly, purple may look dark and dim on the wheel, but it can shine brilliantly in the right company. Even the most 'neutral' color wheel shows you the hues in relation to the white background and each other. Moreover once you take one color out of this relationship to another, that new relationship will create a new color out of it. The color wheel is, therefore, just a fundamental starting point. It would be best to decide which color to pick based on how it looks on the color wheel. Every visual presentation involves figure-ground relationships. This relationship between a subject(or figure) and its surrounding field(ground) will evidence a level of contrast. What does it mean for us? We must understand that colors don't exist separately, each on its own. Even if you paint a red dot on a white background, a

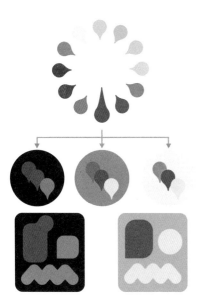

和白色之间的视觉关系也会产生，我们看到的是色彩的
关系，而不是孤立的色彩。

☐ 明度比色相更重要

　　什么是明度？你有没有想过这些色彩术语到底是什
么意思？色彩原理可以通过色相环显示色彩之间的关
系，也教给了我们各种色彩方案，如单色、互补、近似、拆
分互补等。

　　我们的眼睛可以识别色彩之间的关系。如果这些色
彩组合是有秩序或有规律的，就更容易被我们接受。问题
是，这种方法只涉及色相，而色彩远远不止色相这一种要
素。例如，这三个都是红色色相，但你也可以看到它们的
不同。

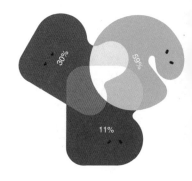

　　基础色彩理论教给我们描述每一种色相、色调、明
暗等通用术语。由于传统绘画将白色、黑色和灰色作为色
彩，通过添加黑色和白色不仅可以降低色彩的饱和度，也
可以用来调整色彩的明暗。在学习理论和原理时，我们可
能会忽略明度的概念，或者将其直接视为亮度，这是因为
它不能被Photoshop这样的绘图软件修改，软件中明度是
色相的默认设置，只能通过改变饱和度和亮度来调整。

　　什么是明度呢？在艺术中，明度指色彩或色相的明
暗程度。一幅画的明度可以明确了它的形式，也创造了空
间的视错觉。它不只是一种色彩的亮度，而是一种色彩与
其他色彩相比的亮度，即相对亮度。因为我们的眼睛并不
是对每一种色彩都同样敏感，所以我们看到的色彩有明
有暗，即使它们都是100%的纯色。如果你知道色彩是如
何产生的，就可以解释这个疑问，白光由三种基本色彩组
成：红、绿、蓝。白色是最明亮的颜色，它的相对亮度（明度）
是100%，但如果它是100%亮度，这意味着它的组成成分
必须小于100%亮度；也就是说：红色是30%的亮度，绿色

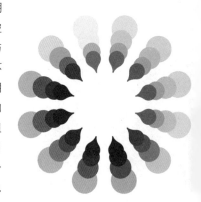

visual relation between red and white is created. We see that relation, not separate colors.

☐ Value Is More Important than Hue

What is value? Have you ever wondered what exactly they mean by these color terms? The color wheel can be used in color theory to show the relationships between colors. Fundamental color theory teaches us about various color schemes, like monochromatic, complementary, analogous, split complementary.

The concept is that our eyes can recognize the relationships between the colors, and if the relationships are organized, the scheme looks consistent to us. The problem is that this method only involves hues, and color is so much more than a hue. For example, these three are the same hue, but you can see what different colors they are.

Fundamental color theory is the general term we use to describe every hue, tint, tone or shade we see. White, Black and Grey are often referred to as color. This comes directly from traditional painting, where saturation is lowered by adding white, and brightness is lowered by adding black. What we might have missed when learning the fundamentals is the concept of value. It's often either ignored or equated with brightness. That's because it can't be modified with any slider in Photoshop. Value is something that all hues have set by default, and it can only be modified by changing their saturation and brightness.

What is value? In art, 'value' means the lightness or darkness of a color or hue. 'Tone' is another word for value. Value in a painting defines the form and creates the visual illusion

of space. It's relative brightness. It's not brightness that color simply has, but it is how bright a color appears to be compared to the others. Our eyes are not equally sensitive to every hue. Thus, we see some hues as darker and some as brighter—even though they're all 100% bright in their pure form. The answer to this curious phenomenon is pretty simple if you know how colors are created. White light is made of three primary hues: red, green, and blue (RGB). White is the brightest color that can ever be—its relative brightness

是59%的亮度,蓝色是11%的亮度。三原色在明度值上显然也是不相等的。因为明度是基于我们的感知而不是色彩在色相环上的位置,所以色相环对我们认识明度没什么帮助。对明度而言,色相环中色相的排列是没有规则和秩序可言的。

正如你所看到的,无论使用哪种色相,一个具有完美平衡感的明度方案都会看起来舒服。正确的色调和明暗有时比色相更为重要,如果你使用了不恰当的明度,那么精心设计的色相搭配可能会大醇小疵。因此,在开始设计时,最好先考虑一下明度关系,与色彩的和谐相比,色相并不像你想象的那么重要。

☐ 色彩心理学普遍适用吗?

在许多设计项目中,尤其是在平面设计中,色彩不仅仅是看起来漂亮,还应该在观者中产生一种预期的心理感应,适时的传递视觉信息,一张IT人员的名片设计不应该让你感觉像生日派对的传单,色彩在这里扮演着非常重要的角色。

基础色彩理论一如既往地为色彩心理学带来一些现成的答案,红色代表能量、战争和爱情,黄色代表欢乐,紫色代表王权,黑色代表严肃和权力……一种颜色能引起一个人的一种反应,也可能引起另一个人相反的反应,这是由于文化背景、先验,甚至仅仅是个人喜好。但即使没有它们,我们也能凭直觉知道什么可行,什么不可行。但是为什么某些颜色有更深层的意义呢?以绿色为例,绿色不再仅仅是一

(value) is 100%. However, if it's 100% bright, that means that its components must be less than 100% bright. And that's exactly what happens: red is 30% bright, green is 59% bright, and blue is 11% bright. The primary colors are not equal in terms of value. Because value is based on our perception rather than the position of colors on the color wheel, the color wheel doesn't help us with values at all. The hues are no longer regular and order at all.

As you can see, no matter which hue you use, a scheme with nicely balanced values will look good, and the correct tints and shades are more important for creating a consistent scheme than hues. Conversely, well-planned hues will never look good if you use the incorrect values. When starting a design, you should focus on values first. Compared with color harmony, hue doesn't really matter as much as you think.

☐ Is Color Psychology Universal?

In many design projects, especially in graphic design, colors aren't simply supposed to look pretty. They have a function—they are supposed to produce a desired reaction in the viewer, giving them some relevant information at that time. An IT staff's business card should evoke not the same emotions as a flyer for a Birthday party, and colors play a significant role here.

Fundamental color theory, as usual, tries to bring some readymade solutions for the psychology of color. Red is associated with energy, war, and love, yellow is about joy, purple is associated with royalty, and black is serious and powerful. A color that can evoke one reaction in one person may evoke the opposite reaction in another, due to culture, prior association, or even just personal preference. But even without them, we have some intuition of what works and what doesn't. However, why do certain colors mean something? Taking green for example, green is no longer just a color. It's now the symbol of ecology

种颜色,如今它成了生态和环境的象征。这种直觉从何而来?多年来,研究人员一直致力于这一领域的研究,试图明确不同的色彩会引发什么样的情绪和身体反应。有证据表明,色彩的意义主要基于文化。色彩可能有一些最初的、原始的含义,所有的文化都是从色彩开始的,但是在世界的不同地方,色彩已经以不同的方式进化了。受文化条件的影响,色彩感知不是独立的,而是与环境中的其他效应相结合的。这意味着你对色彩含义的直觉基于环境这一因素,这也是色彩原理认为一定要遵循的环境规则。蓝色常用于公司网站或设计,比如名片、银行及高科技公司的标识。是因为蓝色能带来信心和专业精神吗? 在全球化的影响下,虽然我们在不同程度上都会受到西方文化的影响,但中、西方传统文化间的差异,使我们对色彩的直觉也相去甚远。例如,在中国,红色被普遍认为是吉祥的颜色,有助于驱恶辟邪,在中东和一些非洲国家,人们把这种颜色却视为危险或邪恶的象征;黄色在中国象征着王权、财富和幸运,在西方是快乐和温暖的颜色,但在拉丁美洲,黄色常常与死亡和哀悼联系在一起;在西方,白色在传统上与婚礼有关,在许多亚洲国家,白色是纯洁的,但在某些情况下,白色却与死亡有关。

我们的大脑天生就会对色彩做出反应,色彩是视觉语言的一种,但不是那种普遍通用的日常语言。正如同一个词在不同的语言中可能有着不同的意味,同一种颜色在不同的文化中也可能有不同的解释。

☐ 制定规则是为了保护现状,还是为了刺激创新?

色彩原理是一种术语,它是从早期慢慢演变而来,用以阐释在艺术和设计中使用色彩的规则和准则。色彩理论和原理指导配色设计,旨在从视觉和心理两方面有效传达审美情趣和设计信息。要设计一个快餐店的标志,就要使用黄色和红色? 为女性设计一款专属的产品包装,粉红

and the environment. Where does this intuition come from? Over the years, researchers have worked to identify exactly what emotions and physical effects are triggered by various colors. There are many works done on exploring in this area, but evidence suggests that the meaning of colors is mostly based on culture. There was probably some basic, primal meaning of colors that all cultures started with, but it has evolved in many different ways in different parts of the world. Color perception is affected by cultural conditioning, and that color is not perceived alone but in combination with other effects in the environment. This means that our intuition about the meaning of colors is based on what you can already see around us, and that has only been confirmed by color theory as a certain rule to follow. Is blue used in corporate sites or designs where strength and reliability such as business cards and in the logos of banks and other high-tech institutions because it brings confidence and professionalism to mind, or vice versa? However, here's the problem: the culture of the West is not the default, nor is it global. It may seem like this when you don't leave the Western cultural circle, whether really or virtually, but there are great numbers of people, for example, Chinese people spend lives inside very different cultures, and our intuitions about colors may be quite different, too. For example, in China, red is Red; the most popular is an auspicious color. It helps to keep evil away, yet in the Middle East and some African countries, people see this color as a symbol of danger or evil. Yellow connotes royalty, property, and luck in China, and it is the color of joy and warmth in the West, but in Latin America, it's often associated with death and mourning. In the West, white is traditionally associated with weddings, but in many Asian countries white is pure, but in certain circumstances, white connects with death.

Our minds are programmed to respond to color. Color is one kind of visional language, but it's not a universal language. Just as the same word may mean different things in different languages, interpreting the same color across cultures may be different.

☐ Are Rules Created to Protect the Status Quo—Not to Spur Innovation?

Color theory is a term used to describe the collection of rules and guidelines regarding the use of color in art and design, as developed since their early days. Color theory informs the design of color schemes, aiming at aesthetic appeal and effective communication of a design message on both the visual and psychological levels. Designing a logo for a fast-

色或柔和的颜色是否更好？如上文所述,使用色彩原理是因为原理易用、好用,但如果过于依赖其中的规则或模式,"千篇一律"的作品则会使设计变得没有新意,甚至是无趣、乏味,创意中最不愿面对的就是单调和乏味。

色彩原理当然充满了规则,它们指明了道路,让一切变得简单,我们也要注意规则和原理都会随着时间而改变,需要与时俱进,对色彩的求新与探索会进一步丰富我们对色彩的理解,也会更加完善色彩使用的原理。跟随潮流是体验新鲜事物的机会,变化是生活的调味品,也许这就解释了为什么一种新颜色会受欢迎,以及为什么会引发消费行为。在20世纪,人们的生活方式也对色彩趋势产生了巨大的影响,无论是用于时尚、涂料还是家具中用色都反映了世界正在发生的变化,一种流行色的兴起可能与更微妙的因素有关,比如该国经济、文化或气候的变化。

当下,我们越来越意识到人们的行为会对环境产生巨大影响,生态学、极简主义和环保的生活方式现在很流行。绚丽多彩的塑料被更天然的材料所取代,少即是多。这个世界似乎已经有足够多的明亮和艳丽的色彩,看看无印良品的色彩系统,它舒适的低饱和度色彩吸引了消费者并塑造了品牌形象。我们面临着一个选择,是仅仅因为规则本身而遵循它的各项要求,还是要敢于打破和寻求创新？以创新为目标,有时就要避免规则的束缚,我们紧跟潮流但更要开创新潮流。虽然基础色彩原理对初学者来说是一个非常有用的工具,但我们也要注意到它的局限性。没有一种原理能囊括所有的设计规则,色彩原理当然也不例外,它更应该被视为一种色彩使用的建议和起点——如果你想拥有色彩的创造力,那么,就让我们一起来不破不立。

food restaurant? Use yellow and red! Creating a package for a product meant for women? Use pink or pastel colors.

As mentioned in the previous section, these rules are used because they work well. However, because they are widely used, they seem to start to appear boring, neutral, and normal. Being boring is usually the last thing on our list of targets when designing something Color theory is full of rules that show you the way and make everything simpler. However, the rules change with time. The novelty of a color creates a desire for the color. Following a trend is an opportunity to experience something fresh and exciting. Variety is the spice of life. Perhaps this explains why we welcome a new color and why this generates consumer activity. In the 20th century, we influenced color trends as much as they influenced us. Colors that gained traction—whether used in fashion, paint, or furnishings—reflected what was happening in the wider world. For example, the rise of color could be connected to subtler elements, such as changes in the country's economic or cultural climate.

We, as human beings, have been becoming more aware of how our actions influence the environment. Ecology, minimalism, and a natural way of eco-friendly lifestyle are trendy now. Flashy, colorful plastic is replaced with more natural materials, and less starts to mean more. The world seems to have had enough of bright, garish colors. Besides, the color system of MUJI attracts customers' wide attention and gives them a sense of comfort. So we are faced with a choice— to follow the tested rules just because they're the rules, or to dare to create something new. To create new trends, we need to avoid the old ones, ignoring the age-old rules with the goal of creating something fresh. It pays off to follow the trends, but it pays off even more to set new ones. While a fundamental color theory is a very useful tool for beginners, in some cases it's more limiting than helpful. No theory encompasses all the rules of design, so color theory certainly can't be one. It should be treated more like a suggestion, like a starting point—but if we want to be creative, we need to learn how to break the rules.

色相环的奥秘！
Mystery of Color Wheel！

色相环

色相环(也称为色环)是色彩关系的可视化表达，是圆环状的色彩光谱。它是一种用于了解色彩及其关系的工具。我们可以在色相环中找到关于色彩的多项元素和信息，例如色相、饱和度、明度、主动色、被动色等。

色相环中的基本语言

色彩是通过定义色彩名称来表述人们如何感知光的特征。我们一般通过色相、纯度(饱和度)、明度(亮度)这三个方面来描述色彩的不同特征。尽管粉红色(红色+白色)、勃艮第红葡萄酒(红色+黑色)和红砖都属于红色，但这些色相在纯度、饱和度、强度、色值方面都有区别。

色相、饱和度和明度

色相、纯度、强度、饱和度、色值等是相互关联的色彩基本术语，都是对颜色特征的描述。

色相

如果你听说过"ROY G BIV"，那么你就知道什么是色相。牛顿将色彩分为七种基本色，每种颜色由单一波长产生：红色、橙色、黄色、绿色、青色、靛蓝和紫色。色相肯定不止七种，但牛顿根据古希腊哲学家的观念，把色相、音符、星期和太阳系的已知物体联系在一起，将色彩归结为七种基本色。

Color Wheel

Color relationships can be visually represented with a color wheel—the color spectrum wrapped onto a circle. The color wheel (also referred to as a color circle) is a tool for understanding color and color chromatic relationships. We can find multiple elements and information in the color wheel, such as the name of colors, degree of saturation, degree of bright, active colors, passive colors, etc.

Basic Language in the Color Wheel

Color is the perceptual characteristic of light described by a color name. Color is described in three ways: its name, how pure or desaturated it is, and its value or lightness. Although pink (red + white), burgundy (red + black), and brick are all variations of the color red, each hue is distinct and differentiated by its chroma, saturation, intensity, and value.

Hue, Saturation and Luminosity

Hue, chroma, intensity, saturation and value are inter-related terms and have to do with the description of a color.

Hue

Have you ever heard the acronym 'ROY G BIV'? If you have, you know what a hue is? Newton divided colors into seven basic hues, each produced by a single wavelength red, orange, yellow, green, blue, indigo, and violet. There are more than seven hues, but Newton focused on these seven per the ancient Greek sophists' belief that hues, musical notes, the days of the week, and the known objects of the solar system were all connected.

饱和度/纯度

饱和度是指色彩的鲜艳程度,也被称为纯度或彩度。饱和度范围从纯色(100%)到灰色(0%)表明了纯色所占的比例。在英文中,有时饱和度和纯度这两个术语是可以互换使用的。美国大多数艺术家更喜欢用Saturation一词来描述色彩的这一特征。

明度

明度是强度的同义词,是指色彩的明暗程度。色彩的明度可以通过增添色彩的亮度即添加白色以提亮该色,反之通过增加黑色会降低色彩的明度。高饱和度的色彩一般具有中明度基调。

深色、浅色和色调

让我们回到上小学时代,如果你有一套64色蜡笔,也许会想,十二色的色相环是怎样变成了64种颜色呢?这就是浅色、深色和色调的变化。你可以通过添加黑色(变暗)或添加白色(变亮)来更改色相的色彩。不同明度的色值、饱和度的变化和一定数量的色相为我们创造了丰富的色调。每种单独的色彩都是一种色相,红色是一种色相,蓝色和紫色是色相,蓝绿色、紫罗兰、橙色和绿色也都是色相。

在为配色方案选择颜色时,色相环可以帮你把白、黑、灰与备选色彩混合创造出更亮、更浅、更柔或更暗的颜色,这些混合后的颜色会产生以下变化:

- 深色是某种色彩与黑色的混合,可降低亮度。
- 浅色是某种色彩与白色的混合,可提高亮度。
- 色调的改变还可以通过添加不同的灰色来实现。

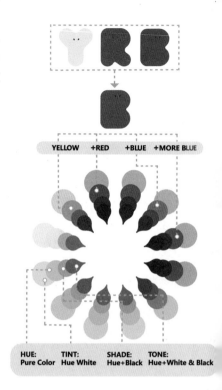

Saturation / Chroma

'Saturation' refers to the purity of a hue, also referred to as 'chroma'. Saturation ranges from pure color (100%) to grey (0%). Sometimes, the terms saturation and chroma are used interchangeably. Most artists in the U.S.A. refer to this characteristic as 'saturation'.

Value

'Value' is synonymous with intensity and refers to the lightness or darkness of a color. A hue's value can be altered by 'tinting' or adding white to a color to create a lighter hue, or 'shading' by adding black to a color to create a darker hue. Highly saturated colors always have medium value.

Shade, Tint, and Tone

Let's go back to that 64-pack of crayons from our primary school. You might be wondering how we got from the twelve colors on our original color wheel to all those crayons? That's where tints, shades, and tones come in. You can change the appearance of a hue by adding black (shadow) or adding white (light). The value of lightness or darkness and the saturation or amount of the hue gives us our shades and tints. Each of those individual colors is a hue. Red is a hue. Blue is a hue. Purple is a hue. Teal, Violet, Orange, and Green are all hues.

When choosing colors for a color scheme, the color wheel gives you opportunities to create brighter, lighter, softer, and darker colors by mixing white, black, and grey with the original colors. These mixes create the color variants described below:

Original Hue

Tint
Adding White

Shades
Adding Black

Tone
Adding Greye

• Shade is the mixture of a color with black, which reduces lightness.

• Tint is the mixture of a color with white, which increases lightness.

• Tone is produced either by the mixture of a color with grey or by both tinting and shading.

色相环的关系和色彩组合

色相环是运用色彩的基本工具,旨在增进对颜色理论、颜色关系和颜色混合的理解。色相环可以表达色彩之间的关系,也可以增进对色彩混合和变化的理解,让我们先从牛顿的12色相环开始认识它们。

原色——红、黄、蓝

原色是无法再分解为任何色彩的基本色。在传统的色彩理论中(用于油漆或颜料),这三种原色颜料是无法被其他颜色混合或合成的,也意味着其他所有颜色均来自红色、黄色和蓝色这三种原色。

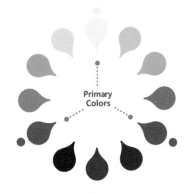

二次色——绿、橙、紫

二次色是通过混合上面的三种原色中的任意两种形成的。下面是二次色合成的一般规则:

- 红色+黄色=橙色
- 蓝色+红色=紫色
- 黄色+蓝色=绿色

请记住,仅当我们使用原色进行混合时上述颜色混合结果才有效。

三次色——黄橙、红橙、红紫、蓝紫、蓝绿和黄绿

三次色是原色和二次色的混合,所以这些色彩的名字变成了"复合词",就像蓝绿,红紫和黄橙。要注意的是,并非每个原色都可以与二次色匹配创建三次色,例如红色不能与绿色和谐地混合,蓝色不能与橙色和谐地混合。这两种混合都会产生类似于深棕色的色彩(除非这就是你想要的颜色)。

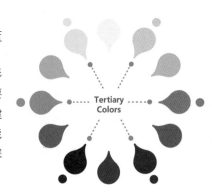

试试看：
尝试用你喜欢的图形
绘制从最亮到最暗的6
个明度范围。
Try this:
In establishing a range
of six values from
lightest to darkest, try
to draw with various
patterns you like.

Color Wheel Relationships and Groupings

The color wheel is the basic tool in playing with color, designed to promote understanding of color theory, color relationships & color mixing. The relationship between colors can be shown with the use of the color wheel. We begin with Newton's wheel is made up of 12 colors as follows.

Primary Colors—red, yellow, and blue

Primary colors are basic colors that cannot be broken down into any simpler colors. In traditional color theory (used in paint and pigments), primary colors are the 3 pigment colors that cannot be mixed or formed by any combination of other colors. That means all other colors are derived from these 3 hues—typically red, yellow, and blue.

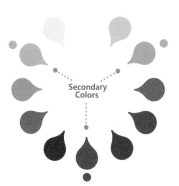

Secondary
Colors

Secondary Colors—green, orange, and purple

Secondary colors are created by mixing any two of the three primary colors listed above. Here are the general rules of secondary color creation:

• Red + Yellow = Orange

• Blue + Red = Purple

• Yellow + Blue = Green

Keep in mind that the color mixtures above only work if we use the purest form of each primary color.

Intermediate or Tertiary Colors—yellow-orange, red-orange, red-purple, blue-purple, blue-green & yellow-green

Tertiary colors are a combination of both a primary color and a secondary color. That's why the hue is a two-word name, such as blue-green, red-violet, and yellow-orange. The most important component of tertiary colors is that not every primary color can match with a secondary color to create a tertiary color. For example, red can't mix in harmony with green, and blue can't mix in harmony with orange—both mixtures would result in a slightly brown

在色相环上将原色与其旁边的二次色混合时创建了下面六种三次色:

- 红色+紫色=洋红色
- 红色+橙色=朱红色
- 蓝色+紫色=紫罗兰色
- 蓝色+绿色=蓝绿色
- 黄色+橙色=琥珀色
- 黄色+绿色=浅黄绿色

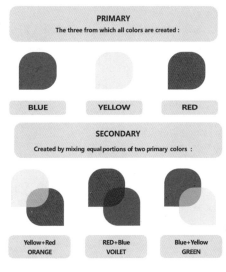

PRIMARY
The three from which all colors are created :

BLUE　　　YELLOW　　　RED

SECONDARY
Created by mixing equal portions of two primary colors :

Yellow+Red
ORANGE

RED+Blue
VOILET

Blue+Yellow
GREEN

色相环中的关系术语

对色轮和颜色之间关系的了解不仅能够帮助我们更好地理解色彩,而且可以在创作中帮我们选取色彩。

单色

从单一色相开始,然后扩展该色的深、浅两种色调,获得更为丰富的单色变化。对于印刷出版,使用单色是一种常用的方式,可以在不增加传统四色印刷费用的情况下,通过添加黑色来处理文本和强调色。

互补关系

色相环上彼此相对的颜色存在着互补关系,这些相对的颜色可提供最大的对比度和稳定性。这种高对比度营造出醒目的外观。想象一下节日的配色:圣诞节的绿色和红色,复活节的黄色和紫色。

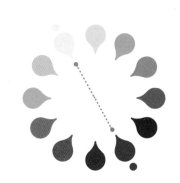

TERTIARY
Created mixing equal portions of one primary and
one secondary color :

Yellow+Orange
YELLOW - ORANGE

Red+Orange
RED - ORANGE

Red+Violet
RED - VIOLET

Blue+Violet
BLUE - VIOLET

Blue+Green
BLUE - GREEN

Yellow+Green
YELOW - GREEN

color (unless that is what you are looking for).

Instead, tertiary colors are created when a primary color mixes with a secondary color next to it on the color wheel below. There are six tertiary colors that fit this requirement:

- red + purple = magenta
- red + orange = vermillion
- blue + purple = violet
- blue + green = teal
- yellow + orange = amber
- yellow + green = chartreuse

Other Terminology in Color wheel Relationships

A thorough understanding of the color wheel and the relationship between colors enables us to understand color better and know how to choose colors for our creation.

小知识：
　　色相环上最接近的两种颜色混合，得到的色彩保持相对的明度。相反，色环上的两种颜色相距越远，调和后就越灰暗。
　　　　——艺术家 简·琼斯

Tips:
　　The closest two colors are on the color wheel, the brighter their mixture will be. Conversely, the further apart two colors are on the color wheel, the duller their mixture will be.
　　　　—Artist, Jane Jones

☐ Monochromatic
　　Start with a single hue and then use shades or tints of that color to expand to two, three, or more colors. For print publishing, using tints of a single color is one way to use color. Without the expense of traditional four-color process printing, add black ink for text and accents.

☐ Complementary Relationship
　　Those colors are located opposite each other on a color wheel. The opposing colors create maximum contrast and stability. The high contrast of complementary colors creates a vibrant look. Think of holidays: Christmas (green and red), Easter (yellow and purple).

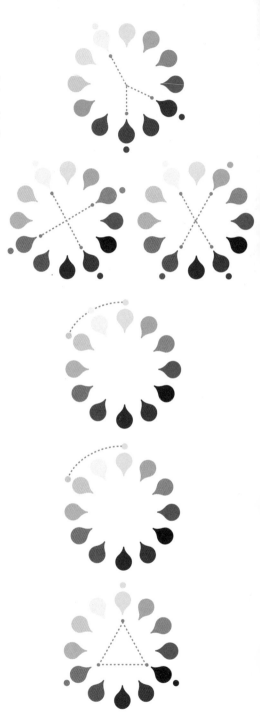

□ 拆分互补关系

　　拆分互补关系的颜色排列是在互补色关系的基础上拆分的,其中一种颜色被其两侧的颜色替代,从而形成三色配色方案。拆分后的两色同属一种色调,并与原补色等距。

□ 双互补／四元关系

　　双互补关系一般有两组互补色,在色相环上彼此相邻且相对,形成"X"形的位置关系。

　　四元关系是双互补色关系的扩展,也是由彼此等距间隔的4个色相组成,在色相环上同样形成"X"交叉,但不是相邻的两色,位置关系呈正方形或矩形。

□ 近似关系（同类色）

　　近似关系是在色相环上彼此相邻的颜色,它们搭配的关系通常宁静而舒适。应用中常常会选择一种颜色为主色,另一种颜色为辅助色,第三种颜色用作强调。

□ 二联关系（类似色）

　　二联配色是在色相环上有间隔的选取颜色,每跳过一个颜色后选择一个颜色,色彩搭配呈现出的是弱对比关系。

□ 三联关系（对比色）

　　三联色是三种彼此等距间隔的颜色,找到三联色的最简单方法是在色相环上放置一个等边三角形,每个角都会对应一种颜色,这三种颜色彼此之间精确地呈120°。

Split-complementary Relationship

A split-complementary color arrangement results from one color paired with two colors on either side of the original color's direct complement creating a scheme containing three colors. These are the colors that are one hue and two equally spaced from its complement.

Double-complementary and Tetradic Relationship

The double-complementary refers to equal two complementary color sets that sit next to and across from each other on the color wheel forming an X.

The tetradic relationship is an extension of the double-complementary color combinations made up of four hues equal distance from one another, forming a square or rectangle on the color wheel.

Analogous Relationship

The analogous relationship colors located adjacent to each other on a color wheel usually match well to create a serene and comfortable ambiance. When choosing, pick one color to dominate, a second to support. The third color is used as an accent.

Diad Relationship

The diad combinations are made of two colors located two steps apart on the color wheel, skipping the color in between.

Triad Relationship

The triad colors are equally spaced from one another, creating an equilateral triangle on the color wheel. The easiest way to find a triadic scheme is to put an equilateral triangle on the wheel so that each corner touches one color. The three colors will be exactly 120° from each other.

积极色与消极色

活跃的积极色往往会激发人的热情,成为能量和创造力的来源;沉静的消极色往往会增进注意力并产生镇定的效果。在色相环上,一般活跃色是暖色,比消极色更能激发观看者的兴趣,消极色(冷色)在视觉上会显得沉静和后退。因此,色相环也可以分为视觉上的积极或消极,积极色在视觉上更具有前进感,相反,消极色与积极色并置时就会显得更加悠远和低调。

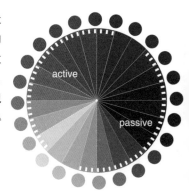

积极色

一般来说,积极色更明亮。它们被认为是"活跃的",因为它们更有可能激发思维,被视为能量的来源。通常与力量、自信、热情和活力等特征联系在一起。

消极色

消极色比积极色更中性、柔和,它们往往能促进精神集中,并有镇定作用。消极色彩与平静、内省、安静和舒适联系在一起。

使用小提示:

要想创建一个令人满意并有效的调色板,那么平衡积极和消极的色彩是很关键的。

• 通常认为前进色比后退色具有较小的视觉重量。

• 饱和度低的色调或亮色看起来比暗色或高饱和度的颜色要轻。

• 尝试改变深色调。某些颜色的深浅意味着不同的含义,例如,明亮的紫红色可以表示奇特,而深紫色则可以表示财富和繁荣。

• 通常温暖、高饱和度、明度高的色彩是"活跃的"和"前进的"。

• 凉爽、低饱和度、暗色是"消极的""后退的"。

• 有些颜色在视觉上保持中立,没有明确的积极与消极感觉。

• 在同一个设计中可以把两类色彩结合使用。因为只使用积极色会让受众感到视觉疲劳,过多的消极色则会有些过于稳重。

Active Versus Passive Colors

Active colors tend to excite both the mind and body and can be sources of energy and creativity. Passive colors tend to increase mental focus and have a calming effect. Most often, on the color wheel, active colors are the warm colors and stimulate the viewer more than the passive colors. Passive colors, which are the cool colors, are more visually receding, which means they appear further away next to more active colors. So the color wheel can also be divided into ranges that are visually active or passive. Active colors will appear to advance when placed against passive hues. Passive colors appear to recede when positioned against active hues.

Active Colors

In general, active colors are brighter. They're considered 'active' because they are more likely to excite the mind and be perceived as sources of energy. Active colors are commonly associated with traits like strength, confidence, enthusiasm, and exuberance.

Passive Colors

Passive colors are more neutral, muted, and toned-down than active colors. They tend to promote mental focus, and often have a calming effect. Passive colors are associated with calmness, introspection, quiet, and comfort.

Tips for Using:

Balancing active and passive colors is a key component of creating an effective, pleasing color palette. Here are our tips for working with active and passive colors.

• Advancing hues are most often thought to have less visual weight than the receding hues.

• Tints or hues with a low saturation appear lighter than shades or highly saturated colors.

• Experiment with different shades. Certain shades of a color connote different meanings—for example, a bright mauve purple can indicate whimsy, while a deep purple might indicate wealth and prosperity.

• Most often warm, saturated, light value hues are 'active' and visually advance.

• Cool, low saturated, dark value hues are 'passive' and visually recede.

• Some colors remain visually neutral or indifferent.

• Combine active and passive colors in the same design. Using only active colors can overwhelm your reader's eye, while using only passive colors can seem a bit lackluster.

如何用色彩进行交流与
表达？
How to Communicate and
Express through Colors?

色彩不仅使设计变得更加鲜活，还可以引起人们的注意，营造一种氛围，甚至影响我们的情感和认知。色彩具有唤醒记忆、激发感官和体现抽象思维的能力。在各种图像中有效地使用色彩，是增强非语言交流与传达的绝佳工具，商业、娱乐、营销与媒体等不仅使用色彩来吸引人们的注意力，而且也在不知不觉地传达着信息。在设计中考虑色彩的心理作用很重要，微软、百度、脸书把蓝色作为标志中的主要颜色，这仅仅是一个巧合吗？通过色彩为客户创造特定的语境，熟悉语境下的色彩识别可以有效地树立品牌形象，也可以更加有效地对潜在的消费者传递品牌信息。总而言之，色彩是非语言交流的一种形式。

那么，色彩到底是如何起作用的呢？

用色彩进行非语言交流

色彩吸引注意力

色彩与宗教、文化、政治和社会背景紧密相连，以无形的方式传播信息。在视觉层面，合理的色彩搭配至关重要，它可以帮助设计师建立视觉流程；反过来，视觉流程的层次结构引导用户快速获取最重要的信息并区分出核心内容。

然而，色彩的搭配组合只是构建清晰的视觉流程的一个方面，色彩本身也有自己的层次结构，每种颜色所体现出的特定情感、感觉和行为，同样会对视觉产生影响。我们需要合理地运用色彩表征与通感等色彩特征，例如运用红色、黄色或橙色来吸引视线、引起关注，这就是手机APP、京东网页和绝大多数平台上重要的通知消息都是红色的原因。另外，如果我们将明亮的颜色和有

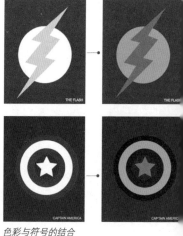

色彩与符号的结合
Color with powerful symbols

Color makes a design come alive, and it can also attract attention, set a mood, and even influence our emotions and perceptions. It can awaken thoughts of memories, stimulate the senses and represent abstract ideas. Using color effectively in all kinds of imagery is a great tool to enhance your non-verbal or visual communication. Businesses, entertainers, marketers, the media, etc., use them to gain our attention and to convey their message quickly without us even knowing it. It is important to consider the psychology of color in the design. Is it simply a coincidence that Microsoft, Baidu, and Facebook all use blue as the dominant color in their logo? Color used in a familiar context can be quite effective at building brand identity by creating a comfortable environment for the customer. Thus, getting across a message to prospective consumers is much easier. Color is a form of non-verbal communication.

So, how does this all work?

Use Color for Non-verbal Communication

Colors Grab Attention

Colors communicate invisibly, and it is tied to religious, cultural, political and social influences. The right color combinations are essential in visual design as they help designers establish visual hierarchy. In turn, visual hierarchy allows users to distinguish the core elements almost instantly and spot the most important information first.

However, it's not just various color combinations that give design structure. Colors naturally have their own hierarchy, which is best defined by the impact of each color that makes on our emotions, senses, and behavior. There are bold colors, like red, yellow, or orange, which are practically unmissable and demand our undivided attention. There is the reason for the notifications on our phone, on Joybuy, and just about every platform are red—they work! If we combine a bright color with a powerful symbol, we can make the message even more effective.

力的符号结合在一起,则可以使信息的传达更加高效。

图形符号与色彩的结合可以加强人们对重要信息的关注度。如果手机小程序中的红色不只是用于关键信息,还作为装饰用色,那么这样的结合效果在关注度上就会大打折扣。如果这些符号使用了蓝色、绿色或灰色等不太醒目的颜色,这样的色彩与符号的组合在吸引力上也会收效甚微。因此,如果需要在某个地方引起读者的注意,最保险的做法还是使用明亮的色彩。

当然,灰色或色彩感较弱的颜色同样有着自己的特征和心理感觉。它们有时用来表示不受欢迎或被禁用的动作,例如当我们看到灰色按钮和选项的时候,自然想到的是无效或不能使用;同时,它们还可以用来简化设计,将不太重要的信息元素设置为灰色,"躲"在画面里,视觉上会更为统一。灰色、白色或浅蓝色之类的色彩就像一枚硬币的两面,合理地运用它们有助于烘托主题和主色调,制造出色彩的对比关系,使重要的元素看起来更加醒目和突出。

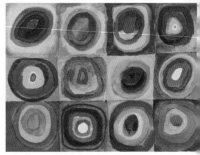

Color Study, Squares with Concentric Circles, Painted by Vassily Kandinsky, 1913

色彩促进识别

人类是非常依赖视觉的动物。我们对视觉信息的记忆比对事实信息的记忆要好得多,大脑渴望视觉信息。在我们处理这些视觉信息之前,使用正确的颜色和悦目的设计不仅可以引起兴趣,而且能够更加长久地锁定注意力。有研究表明,大脑需要四分之一秒来处理视觉提示,而消费者平均注意力的跨度仅为8秒,色彩和品牌识别方面也有着千丝万缕的联系,色彩提供了一种高速的甚至是即时传达意义和信息的方式,无须言语。因此,色彩在品牌塑造中向来重要,如同字

在色彩与形状匹配的响应时间测试中,东京大学的Na Chen团队在实验中发现:设置成"圆形—红色""正方形—蓝色"和"三角形—黄色"的匹配,参与者的响应速度最快。

Na Chen of the University of Tokyo and his colleagues found in the experiment that when mapping circle-red, square-blue, and triangle-yellow onto the same response key, participants responded more rapidly than when they were paired with different response keys.

The power of color-shaped combinations to call attention to important information is heightened when used sparingly. For example, a red triangle that warns people of a critical problem becomes less effective when red is used elsewhere in an App for noncritical reasons. If there are weaker colors for that symbol, such as blue, green, or grey, it just wouldn't have the same effect. If you need to draw the reader's attention somewhere, use a bright color like this.

Obviously, another useful tool in the world of color psychology is using greyed-out or weaker colors to indicate unpreferred or disabled actions. We can see this every day with buttons and options that are grey. It naturally indicates that the option is not desirable. We can also use it to simplify the design. Make less-important informational elements grey and hide them in plain sight. There are two sides to this coin. However, weaker colors, like grey, white, or light blue, help create contrast and make essential elements pop.

Colors Improve Recognition

Humans are visual creatures. We can remember visual information much better than factual and know that our brains crave visual information. Crafting compelling visual content that uses the right colors and eye-pleasing design piques users' interest and locks in their attention long before the information is processed. It takes a quarter of a second for the brain to process visual cues, while the average consumer attention span is just 8 seconds. Brands and color are inextricably linked because color offers a rapid method for conveying meaning and message without words.

For that reason, color schemes are an important part of making brands memorable. That's branding done right. Moreover, the colors play a major role in it. Color is one of the most important elements of a memorable brand—alongside typography, brand name, and graphics. By now, this stuff is so ingrained, and the chances are that when we think of

体、名称和图形一样,色彩是品牌识别中的基本要素之一。只要我们想到著名的公司或某种知名产品时,就会自然地联想到其色彩或色彩搭配,想想百事可乐,想到什么颜色? 你可能会在几毫秒内想到蓝色、白色和红色。色彩是人们对品牌印象最深刻的视觉记忆部分,紧随其后的才是形状/符号,然后是数字和文字,世界上那些知名的品牌都将色彩作为即时识别的关键因素。

小实验:
 让我们进行一个快速实验。闭上眼睛,想想这三个品牌:旺仔牛奶、青岛啤酒和宜家。你脑海中它们的品牌色彩是什么? 是否充斥了红色、绿色以及蓝与黄的搭配。

Let's Try:
 Let's do a quick experiment. Close your eyes and think of these three brands: Hot-kid Milk, Tsingtao, and IKEA. Did you see their brand colors? I bet your brain was instantly showered with purple, blue-with-yellow, and green images.

色彩唤起情感

你在黄色房间里会感到焦虑吗? 蓝色会使你感到镇定和放松吗? 长期以来,艺术家和室内设计师一直认为色彩会极大地影响心情、感觉甚至情感。艺术家巴勃罗·毕加索曾评论道:"色彩就像表情一样,会随情感而变化。"俄罗斯著名画家和艺术理论家康定斯基是色彩理论的最早开创者之一,被认为是抽象艺术的创始人,他认为不同的颜色具有不同的情感特质:

- 黄色—温暖 激动 快乐
- 蓝色—深沉 和平 超自然
- 绿色—和平 稳定 自然
- 白色—和谐 宁静 整洁
- 黑色—悲伤 黑暗 未知
- 红色—热情 自信 活跃
- 橙色—辐射 健康 严肃

我们大多数人都有自己情有独钟的色彩,或者觉得有更适合自己的色彩,颜色显然与情感紧密相连,红色可以增强能量,黄色通常会使人感到快乐,而蓝色被证明可以降低血压和心律,这就是为什么蓝色经常与"放松"有关。如果将具有幸福感的黄色与轻松感的蓝色相调和,可以获得令多数人非常愉悦的绿色。色彩会使我

different companies and products, we automatically think of some color or color combination. Think of Pepsi. Which colors came to your mind? Chances are you thought of blue, white and red within milliseconds. Color is the visual component people remember most about a brand, followed closely by shapes/symbols then numbers and finally words. Many of the most recognizable brands in the world rely on the color as a key factor in their instant recognition.

Colors Evoke Emotions

Do you feel anxious in a yellow room? Does the color blue make you feel calm and relaxed? Artists and interior designers have long believed that color can dramatically affect moods, feelings, and emotions. *'Colors, like features, follow the changes of the emotions'*, the artist Pablo Picasso once remarked. Wassily Kandinsky was one of the first pioneers of color theory. A renowned Russian painter and art theorist, Kandinsky, often considered the founder of abstract art, believed that the following colors communicate the following qualities:

- Yellow—Warm, Exciting, Happy
- Blue—Deep, Peaceful, Supernatural
- Green—Peace, Stillness, Nature
- White—Harmony, Silence, Cleanliness
- Black—Grief, Dark, Unknown
- Red—Glowing, Confidence, Alive
- Orange—Radiant, Healthy, Serious

Most of us have a favorite color or prefer some colors over others. Colors and emotions are closely linked. Red can boost our energy, yellow often makes people feel light, and blue is proven to bring down blood pressure and slow our heart rate, often associated with relaxing. If we combine the happiness of yellow and the relaxing feel of blue, we get green, a very pleasing color for many people. Colors can make us feel happy or sad, and they can make us feel

们感到快乐或悲伤，也会让我们感到饥饿或放松。这些反应植根于心理影响、生物调节和文化烙印。众所周知，心理健康机构的空间使用柔和的色调使患者感到镇定、快乐和放松，米色、浅粉色的墙壁以及薄荷绿的地板是为了创建一个舒缓、和谐和宁静的空间；而在校园的户外空间中，可以使用更多鲜艳的色彩用以激发孩子们的创造力。

IMG: St Faith & St Martin Church of England Junior School

情感影响决定

色彩会影响心情吗？心理学家的回答从来都是肯定的。色彩会影响决定吗？我的回答也是一样！当我们选择产品、服务或品牌时，归根结底是做出决定的过程。例如产品的价格或相关竞品的技术规格，是有意识的比较和选择的结果；同样，也存在无意识的决定，这些应归类为大脑在你有意识地比较之前就已做出的判断。

色彩在我们做出无意识的判断或决定中起着重要作用，不只在选择产品或服务时如此，甚至在日常生活中也会发生。例如红色和绿色，在社会生活与自然世界中都已深深地联结到人们的潜意识中，没有其他两种颜色具有如此对立的含义，最明显的例子就是交通信号灯中的国际颜色代码。我们一直将绿色视为积极前进的颜色，所以像通行、肯定、赞许、接受、向上之类的词都可以与绿色相关。

色彩的选择并非巧合，取决于色彩是如何影响心理的。红色在心理上具有明显的紧迫感，因此，类似"50%折扣"类的标语都是红色的。虽然这些标语可能不像交通信号中的红色会涉及生命安全的紧要关头，但我们看到这些红色标识时自然会与"紧急、谨慎、需要注意"等心理暗示联结在一起。简单而有效的设计方法是使用积极色和消极色来表示"可选"和"不可选"的选项。

hungry or relaxed. These reactions are rooted in psychological effects, biological conditioning, and cultural imprinting. Mental health units are known to use pastel tones on their walls so that patients feel calm, happy, and relaxed. Walls that are beige with a pink tint combined with mint green floors are a popular combination as it is said to create a soothing, harmonious and calm area. At the other end of the spectrum, schools tend to use bright colors that appeal to children.

Emotions Drive Decisions

Does color affect your mood? Psychologists have said 'Absolutely!' to that question for a very long time. Does color drive your decisions? I will say 'Definitely!' to this question. When we choose a product, service or brand comes down to making a set of decisions. Some decisions are very conscious and comparable, such as the price of a product or the technical specification against competing products. Then, there are unconscious decisions. We would class these decisions as to the ones that the brain makes before you even realize them.

Color plays a big part in the unconscious decisions we make, not just in choosing a product or service but also in everyday life. Society and nature have wired red and green so intensely into our subconscious that no other two colors share such opposing meanings. One of the most obvious examples of this connection is the international color code in standard traffic lights. We see green as a positive, progressive color, so words like go, yes, good, acceptable, and up all can be related to the color green.

That choice in color is not by coincidence. Psychologically we see red as conveying urgency. It all depends on how the psychological effects of color are being used. So, with that in mind, think about why so many '50% off SALE' signs are in red. While it may not be a life or death situation like when we are driving, we tie the idea of seeing a red sign to it being something we should read with urgency, caution or attention. In design, a simple and clever way to do this is to use positive and negative colors to indicate a 'correct' and 'incorrect' option.

使用配色方案进行设计表达

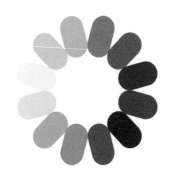

色彩的含义还会因文化和环境的差异而不同,每种颜色都可能蕴含着多重含义。那么该如何选择色彩来正确地传达我们的设计理念,又如何进行色彩配置？我们将从传统的配色方案模式开始介绍,然后讲述怎样为创意项目定制漂亮的个性化方案。众所周知,提高技能的最佳方法就是力学笃行,那么为什么不现在就动手学习一下怎样设计配色方案？

在传统配色案例中找寻灵感

单色方案

单色是最简单的色彩方案,一种色调可以有不同明暗的明度变化,但做得不好时也会很呆板。单色方案中只使用某个色相不同明度的色调,即使用一种色彩的明暗关系构成了单色配色方案。

这是单色配色方案的三个示例。我们从上至下来看这三组颜色。通常,第一栏颜色会用作标题用色,第二栏颜色可以用于正文用色,第三栏颜色也可能会用作背景色(第二栏和第三栏可以在背景色或正文色的选择中互换),最后两栏的两种颜色可用于强调色或小面积的图形用色。

近似色方案

近似色方案在设计表达中通常都有很好的一致性和统一性。近似色配色方案一般都是由具有相似饱和度的相近色相组成,然后通过调节色调上明暗的变化,来增加配色方案的对比度。

这是一个传统的近似色配色方案。虽然它在视觉上

这个"单色方案"让字体闪耀其间。
This monochromatic example lets the type shine through.

这个类似色案例使用了色相环中具有相同色彩倾向的蓝紫色。
This analogous example uses colors from the blue-purple side of the color wheel.

Use Color Schemes for Design Expression

The meaning of colors can vary depending on culture and circumstances. Each color has many aspects, but how do we choose the right colors to express our design ideas? How can we specify the colors we want in the design. We will start with the traditional color scheme patterns and create beautiful custom schemes for our creative projects. As you all know, the best way to improve skills is to practice, so why not set a goal of creating a new color scheme from now?

Inspiring Color Scheme Ideas from Traditional Color Scheme Types

Monochromatic Schemes

Different shades and depths of a single hue. Monochromatic schemes are the simplest color schemes to create, but can also be boring when done poorly. The reason is apparent. Different tones, shades, and tints within a specific hue make up the palette.

The pictures above are three examples of monochrome color schemes. For the most part with these schemes, the first color (if we look at from top to bottom) would likely be used for headlines. The second color would be used for body text or possibly the background. The third color would likely be used for the background (or body text if color #2 was used as the background). Furthermore, the last two colors would be used as accents or within graphics.

Analogous Schemes

These schemes typically do a great job of expressing consistency and uniformity within a design. Traditionally, analogous color schemes all have the same chroma level, but we can add interest to these schemes by using tones, shades, and tints.

This is a traditional analogous color scheme. Although it's visually appealing, there isn't enough contrast between the colors for an effective expression and

很吸引人,但是在颜色之间没有足够的对比用于有效地传达和表现。调整后方案:保持相同的饱和度,在色彩的明暗色调上给予更多的变化,更适合用于海报、网站等设计。

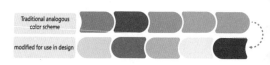

另一个传统的近似色示例。

修改后的方案,增强了对比以获得更好的视觉效果。

互补色方案

互补的配色非常适合表现视觉的平衡感,是一种适用性很广的配色方案。我们已经知道互补色是由色相环上相对立的色彩组成的。与近似色方案的配色方法相同,我们一样可以通过调整色调上明暗的变化获得更多的互补色以及互补关系。但需要注意的是,在基本的两色互补关系中,如果饱和度或色值上相同的补色需要放置在一起,那么可以通过在两色间添加其他过渡色来避免视觉上的过度刺激。

这是另一种饱和度差异较大的互补色配色方案。

小提示:
请注意如果把高饱和度的红色和绿色放在一起,两色的边缘会出现一种"共振效应"。

Tips:
Notice in your designs, how to place the brighter red and green colors next to each other to achieve intentionally a sort of 'vibrating' quality on their edges.

在这个橙蓝互补色配色方案中,橙色左侧的米色和棕色就是调节橙色得出的色调。

performance. We can adjust them to give more variety in tint, shade and tone. Even though they are the same chroma, they are now much more suitable for use on posters, websites or others.

Another example of a traditional analogous scheme.
Moreover, the above theme is modified for use in design.

Complementary Schemes

Complementary schemes are great for communicating a sense of balance and a very versatile color scheme. We have already known they are created by combining colors from opposite sides of the color wheel. Like analogous palettes, adding various tones, tints, and shades can easily expand these schemes. In their most basic form, these schemes consist of only two colors, but colors that are exact opposites with the same chroma or value right next to each other can be visually jarring. We can avoid this by leaving a negative space or adding other transition colors between them.

Another complementary color scheme with a wide range of chromas.

In this orange-blue complementary colors scheme, beige and brown are just tints and shades of orange.

来自Codecademy的这个互补色案例也使
用了强调色。
This complementary example from
Codecademy also utilizes an accent color.

拆分互补方案

在拆分互补方案中,我们要使用的不是色相环中完全相对的两色,而是相对颜色其左右两侧的色彩。需要注意的是,为这类方案选择的色彩,它们之间要有足够的饱和度和明暗色值的差异。

以黄绿色为基本色调的配色方案。

这是一个含有多个较高饱和度色彩的配色方案。

三联色方案

选取色相环上相等距离的三种颜色就可以组成三联色配色方案,它要通过确定主色来平衡三者间的色彩关系,其他两种颜色可以作为方案中的辅助用色。这种方式也可以轻松地创建出色彩感丰富的配色方案。还可以在三联色中选择一个色彩,先将其大幅降低(或提高)明度,用作三联色方案中的中性色,来调和三联色中的其他色调。

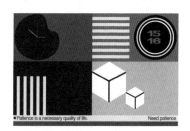

这个三联色案例突出了三原色的搭配。

或者,将一种积极的高纯度色与温和的低纯度色搭配使用,使鲜艳的色调更加突出。

四色配色方案

四色配色方案应该是实现起来最有难度的一种,它们可以通过饱和度和明度上的调整来实现既统一又有丰富变化的配色方案,这里我们通常要添加一点暗灰色或黑色这样的中性色用作强调色或文本色。

或者,使用一种颜色作为主导色,其他颜色都作为辅助色。

Split-Complementary Schemes

In split-complementary schemes, instead of using colors that are opposites, we use colors on either side of the hue opposite base hue. It is important to have enough difference in chroma and value between the colors selected for this type of scheme.

A scheme where yellow-green is the base hue.

Another scheme with a wide range of chromas.

Triadic Schemes

Triadic schemes are made up of three colors from equidistant points on the color wheel, which balance color by selecting a dominant hue and use the two other triadic colors as accents. So it obviously creates more diverse palettes and schemes. Using a very pale or dark version of one color in the triad, along with two tones/shades/tints of the other two colors makes the single color almost work as a neutral within the scheme.

This triadic example highlights the three primary colors.

Alternately, using one very bright hue with paired muted hues makes the single bright hue stand out more.

Tetradic and Tetrad Schemes

Tetradic and tetrad color schemes are probably the most challenging scheme solution to achieve effectively. They can work well for creating color schemes with similar chromas and values. Just add a neutral like dark grey or black for text and accents.

Alternatively, using a scheme like this is to use one color as the primary color and the others just as accents.

低明度配色方案也同样适用。

如何创建自己的配色方案

我们已经讲述了上面几类传统类型的配色方案，下面一起来讨论如何运用新的技巧来完美地展现自己创意和制作专属的配色方案。我们以传统的那些规则作为参考，通过设置自定义配色，创建属于自己并适合自己的新规则、新方案。

3个入门技巧

创建色彩情绪板

我们应该先考虑一下要传达给消费者什么样的"心情"和"信息"。其中，谁是我们的目标受众？我们的设计又满足了哪些需求？我们需要注意设计的背景、主题和氛围，而不是随机的选择色彩。每组色彩都有自己的情感寓意和心理关联，因此必须了解它们才能选择出与我们的设计信息高度契合的配色方案。

情绪板是设计公司经常使用的一种将灵感来源聚集呈现的形式，可以激发创意思考、寻求设计方向、打磨设计过程，从而创建完美的配色方案。学校里的团队项目和个人创作当然也可以使用情绪板工具，情绪板还特别适用于概念驱动方面的工作，例如一些视觉艺术项目、创意写作、摄影艺术等。

创建色彩情绪板时要尝试回答以下几个问题：

- 我们的总体目标是什么？
- 我们的目标受众是谁？
- 我们的产品或服务是什么？
- 我们希望人们在看到或使用产品（服务）时的感觉如何？
- 什么颜色可以帮助我们实现这一目标？

小提示：

情绪板针对一个主题随机地进行图像、文字或样品的拼贴。就像思维导图一样，是围绕着中心概念的多种情绪的可视化表达方式。

Tips:

A mood board is simply a random collection of images, words, and textures focused on one topic, theme, or idea. Like with mind mapping, the visual components of the mood board can be anything branching off that central topic.

It works just as well for darker color schemes.

How to Create Your Own Color Schemes

We have described all of the color schemes of traditional type down. Let's talk about how to actually use this newfound knowledge to form designs that perfect your originality and resonate with your audience. We can use Custom Color Schemes. Instead of following the predefined color schemes discussed above, a custom scheme refers to formal rules and creates some custom palettes of our own.

3 Tips to Get You Started

☐ Start with the Color Mood Board

We could better first think about the mood and message you want to convey to consumers. Who is our target audience, and what needs are we fulfilling with our design? We can't randomly choose colors for our creation, and we should pay attention to what context, topic, and mood of our design. Each color family has its own emotional meanings and psychological associations, so it's useful to be aware of them—this way, we can pick a color that aligns with our design's message.

There's something about pulling all inspiration together in the form of a mood board that can really up the excitement and help us create the perfect color scheme as a result. We don't have to be part of a company to make use of mood boards, as even humble school projects and individual choices can benefit from having one! Mood boards will particularly benefit concept-driven work, such as visual arts projects, creative writing, photographic assignments, etc.

Try to answer the following questions when creating a color scheme:

• What is our overall aim?

• Who is our target audience?

• What is our product / service about?

• How do we want people to feel when they view or use our product / service?

• What colors will help us achieve this?

☐ 60-30-10定律

我们还可以考虑以60%+30%+10%的比例来配置色彩。"60-30-10"定律是一种非常容易遵循的方法,设计人员经常使用这种方法来创建色彩和谐的室内装饰。这种配色的比例可以使视线按照视觉流程有秩序的移动,而且使用起来也非常简单:60%的颜色是主色调,30%的颜色是辅助色或中性色,最后10%是强调色。例如这张图中的墙壁颜色会明显改变房间的氛围,展示了如何使用60-30-10定律。

- 60%——灰色主调。
- 30%——白色或中性色的床上用品和纺织品。
- 10%——天然木材和纤维元素、艺术品和金属落地灯,为空间增添了活力,并体现出多种质感。

☐ 源于自然的色彩搭配

设计师和摄影师一样,善于从自然景象中捕捉色彩,日出、日落、海滩……这些壮观又充满生命力的景象呈现在大地这张奇妙的画布之上。当太阳沉入地平线之后,天空变成许多不同的影调,很多人将日落称为"灵感时刻"。这些来源于自然的色彩搭配有着独特的能力,当你在找寻配色灵感时,大自然肯定是一个绝佳的选择,它让你的配色流露出自然的灵动。作为艺术家或设计师是善于观察自然和利用自然的,生活的周边也处处都有配色的灵感来源,从门口的小花园到著名的艺术品,到处都有我们需要的配色方案,我们可以将其作为配色资源先保存下来,方便为以后的创意实践运用。

> " 自然界的色彩既亲切又具有大家公认的和谐感。在设计实践中,自然界中的色彩组合方式也是解决'情绪反应'的一种方法。
> ——爱德华·塔夫特 "

试试看:

60-30-10规则可以打破吗?当然,如果你足够自信且具有反叛精神,回答是肯定的。但你要知道突破规则会让搭配变得有点复杂,也会带来一定程度的创新。试试再加入一种强调色,将公式之和超过100,变成60-30-10-10。

Let's Try:

Can we break the 60-30-10 rule? Yes, if you're feeling confident and rebellious, but know that you're going to complicate and innovate things a little bit. For example, add a fourth color to the mix by doing something like 60-30-10-10. This will be done by adding a second accent color to your design.

Chrislovesjulia Website

Vincent van Gogh, Irises, 1889 (oil on canvas)

☐ Use the 60-30-10 Rule

We may also consider using colors in a 60%+30%+10% proportion. The 60-30-10 rule is a very easy-to-follow approach that designers often use to create well-balanced rooms using color. The formula works because it allows the eye to move comfortably from one focal point to the next. It's also incredibly simple to use: 60% of your color is dominant hue, 30% of your color is the secondary color or neutral, and the last 10% is for an accent color. Dark wall colors will dramatically change the mood of a room. This bedroom shows how using the 60-30-10 rule can work.

• 60% is in the grey family.

• 30% is white or neutral through bedding and textiles.

• 10% is natural wood and fiber elements, artwork and a metallic black lamp that work together to liven up space and create lots of texture.

☐ Color Combinations Come from Nature

Designers, like photographers, often turn to sunrises, sunsets, beach scenes to capture some spectacular and vibrant color palettes painted across Mother Nature's canvas. The sky turns so many different shades as the sun sinks behind the horizon that you find many saying that sunset is a time of inspiration. They are unique schemes that can be adapted to suit your needs and will always look natural. Nature is a great place to turn to when you need inspiration for a color palette. As artists and designers, they can turn to these amazing nature senses and photos not only to inspire but to capture some of those color palettes for their own work. Save them and use them later in future originality. We can find ideas for color schemes in all kinds of interesting places, from a small garden at the door to famous works of art.

Nature's colors are familiar and have a widely accepted harmony. Engage color combinations found in nature are especially useful for addressing another design consideration: emotional response.

—Edward Tufte

鲜艳的绿叶和五彩缤纷的花儿们带来了春天的色彩,嫩绿和珊瑚色组成的色彩关系鲜艳夺目又抓人眼球,这种配色不仅可以用于春、夏主题的活动海报,用于青春时尚的主题也会有耳目一新的感觉。

对于复古或老式海报的风格,这种"焦橙色"配色方案非常适用。

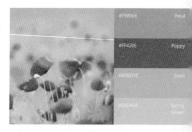

▓ 六步指南

☐ 选定主色调

第一步就是选择一种主色调,要确定1-3种主导色和3-5种辅助色。那么怎么选择呢?如果我们是设计师,而且客户已经有了现成的标识形象系统,那么很幸运,系统中的色彩可以作为首选的配色方案。我们可以挑选衍生品、辅助图形或网站页面上配色等这些形象系统中最常用的色彩作为主题色/主色调。假如没有这些便利的条件,就需要我们从头开始思考和建立配色,前面讲过的"3个入门技巧"也可以让我们大致知晓哪些方式可以轻松上手创立个性化的自定义配色方案。

主色调还与表现的主题相关。考虑一下设计作品中描述的主题,是运动、时尚、美容还是商业?依据色彩理论,梳理那些常见色彩的心理暗示和对下意识行为的影响,考虑与该主题相关联的特定情绪,它是散发着可爱和时尚气息的传单,还是某种充满斗志的体育手册?我们通常通过设定关键字来确定主题,例如女性化、欢快、严肃或优雅。

☐ 确定颜色数量

了解基本的色彩对比、组合、主色调、强调色等色彩理论知识将帮助我们创建精简灵活的配色方案。色彩的调和也指使用数量有限的颜色,在确定

DOMINANT

Fresh greenery and colorful blossoms make springtime a welcome sight after a long winter. This color scheme features bright shades of green and coral that will make your design pop. These types of effects might be used for a spring or summer-season event poster or Perhaps an advertisement that wants to come across as fresh and youthful.

This Burnt Orange color scheme could work really well for a retro / vintage poster.

6-Step Guide

☐ Find Your Dominant Color

The first step we should take is to choose a dominant color. It's time to decide on 1-3 dominant colors and 3-5 secondary colors. How do we pick one? If we are designers and already have a logo or an existing branding—we are in luck because we likely already have a primary color that belongs to it. In that case, we can choose based on existing materials material. We usually won't use every color scheme for each collateral item, logo variation, or page of a website, so determine which colors will be used most often. Yet, even if we start from scratch, the information above should at least have given us a general idea of which basic color would be a good option. It goes through much of what we have covered '3 tips to get you started' are effective ways already.

The definition of the color theme is related to the subject. Consider the topic that we are trying to portray in the design piece. Is it sports, fashion, beauty, or business? Do a little research on color theory, find out what some common colors can do to people psychologically and subconsciously when used correctly. From there, think about a specific mood that we would like to associate with the activity. Is it a cute fashion flyer or an aggressive sports brochure? Do we usually determine the theme by setting keywords, such as feminine, cheerful, serious, or elegant?

CONDARY ACCENT

☐ Decide How Many Colors to Pick

Knowing the fundamentals of contrast, color

了首选的主色调之后,就该选择强调色,并且要确定颜色的数量。是必须使用5种或6种颜色吗？当然可以根据自己的实际需要,可多可少地增减颜色。

在搭配中,除非有意要使用彩虹式的多色,否则还是要避免使用过多的颜色。智利图形设计师Rodrigo German建议使用3种颜色,不要因为过多和过于瞩目的颜色而干扰了图形的完整性。他还建议,当必须使用3种以上颜色时,可以通过在色彩中添加肌理以弱化过多色彩在视觉上的冲击和影响。尝试反问自我是否可以减少配色中的色彩数量,如果可以,那就试试减到神奇的数字"3"。就像前面提到的三联色方案,这种3色搭配对于初学者来说是不错的选择,在色相环上选取三个距离相等的色彩很容易获得良好的效果;拆分互补色这种方法也是3色配色。像内容丰富的网站、小册子等,尤其需要在视觉上限定区域的设计,如一些侧栏、标题、表格等,还可以通过调整主色的明暗变化以增加色彩数量,这样既可以提供超过3色且变化更为丰富的色彩选择,也不会与现有的配色方案形成冲突。

☐ 选择辅助色

确定了色彩数量之后,就该考虑具体的配色了。辅助色是用于显示设计中不太重要的信息,例如网站设计中的次要按钮、子标题、活动菜单项、问题解答、推荐、背景或补充信息等,室内设计中的家具、地毯、木质装饰和织物等。辅助色搭配的关键是改变色调,这是增强设计趣味性的另一重要技巧。

那么为什么要添加辅助色？辅助色就是用来辅助表现主导色彩的颜色。虽然辅助色是依附于主导色而设定的,但辅助色和主导色是相辅相成、各有所用。对于含有大量产品图片、支持材料、可下载资源等信息页面的网站,尤其如此。不同的设计创意领域,都会存在类似的色彩问题,我们需要借鉴色彩使用的经验和技巧将其挪用

小提示:

Graphic Box的设计师Salome建议:"在继续进行细节处理之前,先对色彩主题进行粗略定义,例如:我要的是浪漫的紫色,或我想要可爱的粉色。"

Tips:

Salome, the designer of graphic box: 'Salome, the designer behind Graphic Box, suggests coming up with a rough definition of the color theme before you go ahead and work on the details. For example: I need a romantic purple or I want a cute pink.'

combinations, and dominant and accent colors will be helpful in creating streamlined, versatile color schemes. Color harmony is also using a limited number of colors in a color scheme. After picking a dominant color for our primary, it's time to decide which accents will be used and how many others will use. 5 or 6 colors should be used? Of course not. It is free to add more or fewer colors depending on the aesthetic we are trying to achieve.

Unless we are going for a deliberate, full-on rainbow look, avoid combining an excessive amount of colors. Rodrigo German, a Chilean graphic designer, recommends using three colors to keep your graphics looking clean and not overwhelming. When using more than three, he suggests adding in textures to tone down some of those additional colors. Check out our scheme and ask ourselves if we can cut down the number of colors in the schemes—ideally down to the magic number: three. A triadic color scheme where the colors are equally spaced around the color circle is a good choice for beginners because it is easy to get good results. The split-complementary color scheme is another good alternative.This is especially true for content-rich web pages, brochures, or where you need to visually separate sidebars, captions, tables, etc. A good alternative is to use shades and tints of your main colors. Tints and shades can be used to provide more than three additional color options without clashing with your existing color scheme.

☐ Choose Secondary Colors
After giving a thought to the number of colors, it's time to choose them. Secondary colors are used to highlight the less important information on your design such as secondary buttons, subheadings, active menu items, backgrounds, or supporting content like FAQs and testimonials in website design, or accent furniture, area rugs, wood trim, and textiles in interior design. The key here is to vary the tones of this accent color to keep the design interesting.

What is the point of adding secondary colors? Sometimes a design will require more than just a few primary colors. Normally, secondary colors are defined by the primary dominant colors, and that neither can exist effectively without the other. This is especially true for websites packed with content and landing pages, such

到我们的创意活动中。例如,室内设计师必须综合考虑设计中的材质、物品和配色方案结合后的空间效果,他们使用的"60-30-10"的配色比例,这里的30就代表了辅助色所占的比例。

☐ 找寻中性色

在色彩对比中,中性色表示几乎没有色彩倾向的颜色,或者说是饱和度很低的颜色,因此,可以把中性色形容为"一种看上去没有颜色的色彩"。当然,中性色仍然是一种色彩,包括米色、奶油色、象牙色、白色、灰色、棕色和天然木材色等。中性色的作用也非常的突出,除了主色和强调色以外,我们还要关注对中性色的选择。

从中性色定义上看,它们是不饱和色或是饱和度极低的色彩,因此它们适合作为背景色创造出松弛的视觉空间。平面设计中的中性色与"留白"的功能是很相似的,它们可以突出画面主题、减少视觉负担。恰当的中性色会使主要元素更加出彩,中性色留出的视觉空间可以让人们更好地吸收和优化信息。

☐ 调整明度和饱和度

不管是使用单色、类似色还是互补色的配色方案,清晰的配色都应包括高、中、低明度色调的平衡混合。调整明度和饱和度确保配色中清晰的对比关系,不仅可以活跃视觉效果,而且可以给予原有的主色或辅助色更多的色彩变化,增添了使用时的灵活性。

请查看这三组配色方案,5个一组的配色中有包含低明度的中性色吗?如果没有,请选择其中一种颜色通过降低明度或饱和度以创建出低明度的中性色;或者将现有颜色之一直接替换为另一种具有较低明度的中性色。

可见,要使配色能够传达出不同的活力,可以尝

试试看:
尝试几种常用的中性色制作方法:
• 黑和白混合成灰色的中性色。
• 创建棕色调的中性色——两种互补色／三原色的混合。
• 一种低明度中性色和一种高明度中性色混合成的中性色(通常是灰色)。
• 具有主色色彩倾向的低／高明度的中性色。

Let's Try:
There are a few different ways to make neutral colors:
• Blend black and white to make grey.
• Create brown in two ways—by blending two complementary colors together, or by blending all three primary colors together.
• Good choices are one dark and one light neutral color (usually greys).
• Use different shades of dominant colors.

小知识:
关于中性色,还要记住的是:自然形成的元素本身往往是中性色,它会为中性空间的设计添加可爱、宁静的元素,同时又可以与主色调和谐的搭配,不会过多分散注意力。

Tips:
Something to still remember about neutrals: nature-based elements tend to be inherently neutral themselves and thus provide a lovely, restful complement to a neutral space's de-coration. They should work well with your dominant colors and, at the same time, not distract too much.

as products, enablement materials, downloadable assets. Different design fields share common challenges when dealing with color. Interior designers, for example, have to harmonize spaces using textures, objects, and color schemes that blend well together. Try to delve into other creative fields and discover their rules of thumb when it comes to color use. In this respect, the 60-30-10 Rule is one of them, and the 30—secondary color represents the proportion in a color scheme.

☐ Find Neutral Colors

Neutral, in terms of color contrast, means lacking or being without color. In other words, unsaturated with color. But neutral colors are still colors, so a better description would be something like 'a hue that appears to be without color.' These colors include beige, cream, ivory, white, grey, brown and natural wood. That technicality is incredibly important in distinguishing what makes a neutral color, well, neutral. Neutral colors are in addition to primary and accent colors.

Neutral colors are by definition unsaturated (at least, they should have very little saturation), allowing them to serve as the relaxing background to space. The same function of neutral color in graphic design is much like that of white space—to give users a break and allow them time to better digest and prioritize information on the page. Proper neutral colors complement the main elements and give the eye a resting place.

☐ Adjust Value & Saturation

A distinct scheme includes a balanced mix of light, medium, and dark tones, regardless of whether it uses a monochromatic, analogous, or complementary color scheme. Make adjustments to the scheme to ensure that the colors we are using include an array of light and dark tones to add contrast and give us more versatility when we implement brand colors into your collateral items.

For example, take a look at 5-color schemes. Do you have at least one dark neutral in the mix? If not, add black to one of the colors to create a darker shade or replace one of your existing colors with a darker color. The same is one light color in the mix. Add white to one of the colors to add a lighter shade or replace

试调整饱和度和明度来创造出微妙的色彩关系。通常，处于明度序列较低位置的色彩传达出的色彩感受力更强大，就像酒红色比浅粉红色更有视觉张力，深灰的木炭色也比鸽子灰更具威严，淡淡的冰蓝色的感觉是柔软和安静，而海军蓝则具有强大的力量感。另外，几乎不含灰色的高饱和度色彩一般生动而极具活力，传达的是一种趣味甚至狂热的氛围，中低饱和度的色彩因具有或多或少的灰色底色，因此它们较为静谧且柔和。作为塑造色彩张力的工具，饱和度以深奥的方式影响着图像的整体构图和氛围，色彩不同的明度和饱和度均影响着创意的生成和表现力的塑造。

□ 使用头脑风暴

有经验的设计师经常从身边的事物中获得灵感。头脑风暴将我们的灵感或感觉通过色彩、图像、视觉元素以可视化方式呈现，梳理灵感和线索、激发新的创意。头脑风暴与传统的学习方法相比，被证明更能显著提高对大脑中储存信息的搜索能力。

在头脑风暴中使用视觉和多感官提示的方法：

• 从广告、知名品牌、著名的艺术品中都能找到配色灵感。

• 使用网络资源浏览配色方案，汲取灵感生成个性化方案。

• 借助多感官体验去调整配色，例如味觉和嗅觉的介入。

通过将视觉、味觉等多种感官联系起来，色彩成为更强大的工具。2009年，研究人员发现，在头脑风暴时被蓝色包围的参与者产生的创意是被红色包围的两倍。

one of your existing colors with a lighter color.

To make a color convey power excitement, try adjusting the value and saturation—how light, medium, and dark the color is. Generally, The darker a color, the more power it conveys. Burgundy is more powerful than light pink; deep charcoal grey is more commanding than dove grey. The faint ice blue feels soft and quiet. However, navy blue feels more powerful. Besides that, fully saturated colors are vivid and rich because they have no grey in them, and it conveys a fun-even wild-mood. Less saturated colors have grey undertones, so they are muted and soft. As a tool for shaping color expression, saturation affects the overall composition and mood of images in profound ways and is worth exploring as we generate our color creation.

☐ Brainstorm When Needed

Experienced designers often take inspiration from the world around them. Combining imagery, color, and visual-spatial arrangements can help surface emotions and feelings spark fresh, new ideas. Brainstorm is also being proven to significantly improve information recall in comparison to more conventional methods of learning.

There are many ways to use visual and multi-sensory prompts in brainstorming:

• Find ideas for color schemes in all kinds of interesting places, from advertising and branding to famous works of art.

• Use a web resource to browse color schemes or palettes or generate our own.

• Think about other senses, like taste and smell, to inform color scheme.

By connecting multiple senses, like vision and taste, color becomes an even more powerful tool. In 2009, researchers found that being surrounded by the color blue while brainstorming prompted study participants to produce twice as many creative ideas as those surrounded by the color red.

7种色彩工具

计算机辅助的方式会帮助我们创建配色方案时更为高效。为了帮助学生在"色彩创意"课程中的学习,我们推荐了7种数字辅助色彩设计工具帮助构想配色方案。

☐ Color Hunt——是一个免费和开放的色彩灵感平台,有数以千计时尚的可选配色方案。

☐ Color Fars——是一个好用的工具,可以通过拖放图像、插入网址或选择随机值来轻松创建调色板。

☐ Color Hex——是一个提供颜色信息的免费色彩工具。只需在搜索字段中键入颜色值,它就会为你的设计生成匹配的调色板。

☐ Color Explorer——是一个在线服务工具。选择颜色或从图像、超文本标记语言/级联样式表或从网址中导入,把它们添加到一个集合中,找到匹配颜色。

☐ Coolors, Adobe Color CC & Paletton——这三个数字配色工具比较相似,其中Paletton的差异在于不局限于五个色调的选择上。当你有主色后,想要探索更多的色调搭配时,它们都是很棒的配色工具。

以上只是几个配色辅助工具的示例,随着网络和数字技术的迅猛发展,例如Android,iOS,PS和AI之类的数字辅助色彩工具系统会越来越广泛地用于色彩组合设计中。

7-Color Tools

To help students choose the best colors in the Color Creation project, we resorted to a series of digital tools that facilitate choice, making creating color schemes a lot easier and combining colors effectively. 7 color tools that will bring up your scheme ideas.

☐ Color Hunt—A free and open platform for color inspiration with thousands of trendy hand-picked color palettes.

☐ Color Favs—This is an easy-to-use tool where you can easily create a color palette by dragging and dropping your image, inserting a URL or selecting random values.

☐ Color Hex—This is a free color tool providing information about color. Just type any color values in the search field and ColorHexa will generate matching color palettes for your designs.

☐ Color Explorer—A nice online service to create color schemes. Pick colors or import them from images, HTML/CSS, or a web address. Add them to a collection, find matching colors and a lot more.

☐ Coolors, Adobe Color CC & Paletton—Paletton is similar to both Coolors and Adobe Color CC with the main difference being that it is not limited only to 5 tones. This is a great tool to use when we have primary colors and want to explore additional tones.

Obviously, these are just a few examples of color aids for creating color schemes. With the rapid development of the networks and digital technology, the digital assisted color tools system is using more and more extensively in color combinations, such as Android, iOS, PS and AI.

如何在创作中运用
色彩的力量？

How to Use the Power of
Color in Your Creation?

色彩可以说对每个人都很重要,它不仅影响情感,而且与信仰与文化也密不可分。为什么色彩的寓意在我们的生活中扮演着如此重要的角色?它又对我们的心理和生理有着什么影响?我们又该如何把握色彩的这些力量?

色彩的寓意与象征

▨ 色彩的寓意从何而来?

色彩的寓意或者说含义,源自于心理影响、生理条件和文化背景三个因素。数百万年来的生物进化已经在色彩、身体及情感之间建立了微妙的联系,其中的一些关联直到最近才被发现。这些关联可以激发特定的情感、行为,可以说色彩指出了一条通向人们心灵的新捷径。我们时而会提到色彩感觉,"感觉"有时比那些基于事实和数字的理性思考更有力量,对"感觉"的把握、对色彩含义的深入理解可以促使我们的设计创意与表达方式更加有效。色彩自古以来就具有强大的象征意义,与我们的日常生活也息息相关,它会使我们的穿着更合时宜,使我们的家居与装饰更具品位。

▨ 色彩寓意会变化吗?

色彩的象征寓意是以色彩来代表特定的文化表征或社会群体。语境、文化和时间是思考色彩象征意义的重要因素。对于不同文化背景和社会环境的人群而言,色彩有着不同的寓意和感觉。当你想到中式传统婚礼的时候,眼前会浮现什么色彩?中国国旗、春节或元宵节又能给你怎样的色彩印象?当然,对色彩的认知可以非常个人化,对色彩寓意的解读是与个人的经历与文化背景密切相关。例如,白色在许多西方国家通常代表纯洁和纯真,但在东欧一些国家和中国却被视为哀悼的象征。随着时间的流逝,很多色彩也衍

Colors hold significance for people around the world. Not only do colors influence emotion, but they also hold meaning in religion and various cultures. How significant is the meaning of colors and why do they play such a significant role in our lives? What impact do they have on our bodies and mind? And how do we use the powers of color in our creation?

Color Meaning and Symbolism

Where Do Color Meanings Come from?

Color meanings stem from psychological effects, biological conditioning, and cultural developments. Millions of years of biological conditioning have created certain associations between colors and objects or emotions, while some associations may be more recent. Understanding these associations will give us a shortcut to people's hearts, provoking a specific emotion and maybe even a behavior. Feelings are much more powerful than rational thoughts based on facts and figures, and applying color meanings, and color symbolism will make our design idea and efforts much more effective. Colors and color meanings have been powerful symbols to mankind since the dawn of time. If we understand the meaning of colors, we can match our clothes to our intentions for the day, or we can decorate our home in the colors that reflects our true self and what is most important to us.

How Color Meanings Change?

Color symbolism is the use of color as a representation or meaning of something that is usually specific to a particular culture or society. Context, culture, and time are certainly important factors to consider when thinking about color symbolism. Depending on the culture or society, colors may symbolize different things for different people. Consider China as an example. What colors come to mind when you think about a wedding? What about the flag? How about the Chinese New Year or Lantern Festival? People's feelings about colors can, of course, also be very personal. Color meanings may have something to do with your past, your experiences, or your culture. For instance, while the color white is often used in many Western countries to represent purity and innocence, it is seen as a symbol

生出了新的寓意并逐步为大众所接受,例如在西方传统和当下的中国文化中,粉色是女孩的象征,蓝色则更多是男孩的专属色彩。

▓ 日常生活中的色彩心理学

"红灯停、绿灯行",除了遵守交通信号灯的指示外,周围环境还会怎样影响着你的行动和心态?某个特定的空间是否会令你烦躁不安或是让你放松和平静?这很可能是空间中的色彩影响着你的情绪。产品、网站、名片和标志的色彩应用同样也会影响到我们。色彩融入日常生活的方方面面,就我而言,我会立即想到某些标志、名片和手边文具的用色,还有网站、社交媒体、电子邮件、演示文稿中的用色,以及商业营销中传单、产品包装中的色彩应用。这些设计用色一定是与个人风格和文化背景密不可分,它会体现在我们的房间装饰和穿着打扮等日常生活中,并会引发一系列的审美体验和情感效应。

▓ 作为象征符号的色彩

对大多数人而言,很多形状和色彩都具有心理认知共性,例如:水平线体现的是稳定,而对角线是动态的;暖红色像火焰一般灸热,冷蓝色像天空和海洋一样流动多变……我们的思维对色彩做出反应就像程序一样,知道如何将色彩和特定的形状组合起来以促进信息交流的效率,色彩是用一种非语言的即时方式传达信息。

品牌的形象识别包含了形状、符号、数字、文字等视觉信息,色彩作为视觉信息的一部分,最容易被人们记住,也是最先被接收到的讯息。当然,当色彩与形状结合后,色彩的象征意义变得更加复杂和多元,比如将色彩与品牌结合,色彩表现出的力量既具有情感性又兼具实用价值。从情感上讲,色彩会影响消费者识别品

更多好玩的颜色寓意:
Blue—
You look a bit blue. 你看起来有点忧郁。
Black and blue (伤得) 青一块紫一块
Green—
Green with envy 羡慕嫉妒恨
Green hand 生手
Red—
Red represents good luck (中国的)吉祥色
In the red 亏损
Yellow—
A yellow-bellied coward 胆小鬼
He's such a yellow belly. 他真是个懦夫。
Purple—
Courage & Bravery 勇敢勇气
The Purple Heart 美国的紫心勋章
Black—
Black widow 黑寡妇

试试看:
思考一下色彩和现代符号间的关系。
Let's Try:
Think about the relationship between color and modern symbols.

of mourning in many Eastern European countries and China. Other colors have developed cultural meaning over time, and their meanings have been adopted by society, such as pink as a color for girls and blue for boys in Western cultures and even in today's China.

Applying Color Psychology to Everyday Life

Red means stop and green means 'go'. In addition to this universal message from traffic lights, did you know your surroundings may be influencing your action and state of mind? Do you ever notice that certain places incredibly irritate you? Or that certain places are especially relaxing and calming? There's a good chance that the colors in those spaces are playing a part. Likewise, the colors used for a product, website, business card, or logo cause powerful reactions. There are all sorts of places where color comes into play in our daily life. I, for my part, might immediately think of branding elements like the logo, business cards, and stationery. Color choices will also be meaningful across online communication and marketing materials: website, social media, emails, presentations, as well as offline tools like flyers and product packaging. They have distinctive personal and cultural associations and provoke a range of emotional and aesthetic responses that are reflected in the clothes we wear, the way we decorate our houses, and the choices made by designers and artists.

Color as Symbol

There are natural—or universal—associations evoked by shapes and colors that are common to all of us: For example, a horizontal line is stable and a diagonal line is dynamic. Red is hot and full of fire, blue is cool and watery—or intangible like the sky or sea. Colors and shapes work in harmony with each other to communicate. Our minds are programmed to respond to color. Color offers a rapid method for conveying meaning and message without words.

A brand's logo and visual identity will comprise a number of visual cues, such as shapes, symbols, numbers, and words. Color, a visual component, people remember most is color and see color before they absorb anything else. The symbolism becomes more complex than color is used in combination with a basic shape. When it comes to branding, the power of color is both emotional and practical. On an emotional level, color can affect how consumers feel when they look at a brand, while on a practical level it can help a brand stand out in the crowd.

牌时的感受；在实用性层面，色彩配合其他设计元素共同塑造品牌形象，使其脱颖而出。

　　影响色彩象征意义的另一个因素是色彩搭配和组合后产生的新寓意。例如，特定红色和绿色的组合代表了西方传统的圣诞节。有关色彩与品牌关系的大量研究还表明，对产品的快速识别90%依赖于色彩，消费者通过色彩辨别品牌的个性，色彩对品牌塑造的成功与否取决于人们对品牌色彩的感知是否准确，即该色彩寓意与品牌个性间的适切性。

试试看：
快速检测图中哪种色彩组合是真正的"百事"图标。
Let's Try:
Is the real Pepsi easy to detect in the image below?

"如果想要营造刺激环境或是想要增进食欲？那可以考虑使用黄色或橙色。"

色彩寓意与象征的运用策略

　　色彩心理学是在自然欣赏和社会活动方面研究色彩对人们的刺激和影响的学科。科学家们在实验和研究中发现色彩确实能影响人们的情绪，一些色彩使我们感到快乐、放松，而有些使我们感到悲伤和焦虑。另外，色调的改变也一样会引起象征意义的变化，即使是同一颜色也是一样。例如，蓝色是许多科技企业的钟爱色，因为它能够传达坚实、信任和安全的感觉，但这种蓝色应该是IBM蓝色或者明度较低的蓝色，而天蓝色就不会有这样的效果。可见，色彩心理学中蕴涵了很多有趣又耐人寻味的知识。

　　那么，当我们确定最终的配色方案之前，是否可以试着反问自己选定的色彩具有哪些象征寓意呢？比如"它们能够传达我们想要的情绪吗？它们对目标受众有足够的吸引力吗？"这些看似简单的问题会带给我们在色彩心理与情感寓意方面的启发或答案。在本书中，我们将提供17种色彩心理应用指南，以帮助大家为自己的创意设计选择理想的色彩。

YELLOW
Optimism
Warmth
Happiness
Creativity
Friendliness

ORANGE
Confidence
Warmth
Innovation
Friendliness
Energy
Bravery

GREEN
Health
Hope
Nature
Growth
Freshness
Prosperity

BLUE
Trust
Loyalty
Dependability
Logic
Serenity
Security

BROWN
Serious
Earthiness
Reliability
Authenticity
Warmth
Support

BLACK
Sophistication
Security
Power
Authority
Substance

GREY
Solid
Timeless

Colors take on new meaning when combined with other colors, that is another factors that influences the symbolism of color. For example, red and green are the colors of Christmas in Western cultures. Several studies on the relationship between color and branding reveal that up to 90% of snap judgments made about products can be based on color alone, that colors influence how consumers view the 'personality' of the brand in question, and that the relationship between brands and color hinges on the perceived appropriateness of the color is the right 'fit' for the particular brand.

'Want to create an environment of stimulation or whet people's appetite? You might consider utilizing the colors yellow or orange.'

RED
Flower
Excitement
Strength
Power
Passion
Energy

VIOLET
Wisdom
Luxury
Wealth
Spirituality
Sophistication
Royal

WHITE
Cleanness
Clarity
Purity
Simplicity
Freshness

The Art of Using Color Meaning and Symbolism

There is a whole field of science dedicated to studying the effects of color on human behavior—it's called color psychology. Through many experiments and research, scientists have established that colors indeed evoke emotions: some make us happy and relaxed, while others tap into darker feelings and can make us anxious or sad. Color psychology is pretty fascinating stuff. One thing to note as well is that the shade of colors also affects response, even the same color. Blue is great for businesses because it conveys grounded, established trust and security... but only if it's that particular shade of IBM blue or a little darker. Sky blue is not going to get the same response.

We may have an idea of the color schemes for design to be, but before you set anything in stone, try to look at what the colors we are thinking of using mean. 'Do the colors convey the right emotions and are they attractive to my target market?' might seem like a silly question, but we can get a lot of insight by looking into the psychology of colors and emotion. This book will provide a 17-color guide to help you choose the ideal one for creative design.

暖色系包括红色、橙色和黄色，以及衍生出的暖色

暖色是充满活力、激情的积极向上的色彩，它是火焰红、秋日黄和那些日落日出时温暖而绚丽的色彩。暖色中的红色和黄色均是原色，在色相环中它们两者之间是橙色（二次色），可见暖色是由暖色调和而成，并不需要和冷色结合。

黄色——乐观、开朗、活泼、快乐

太阳维持着人类星球的生命系统，黄色是太阳的象征，因此它代表了生命、能量、幸福、希望和智慧。文森特·凡·高的"向日葵"几乎全部用黄色绘制，没有阴影。它表达的是太阳的光芒而不是仅仅为了描绘花的形态。"向日葵"系列的绘制是为了欢迎凡·高的朋友保罗·高更来到阿尔勒的黄房子，他使用黄色作为希望和友谊的象征。

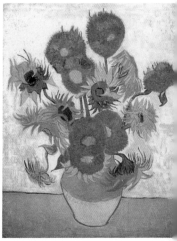

Vincent van Gogh
Sunflowers, 1889 (oil on canvas)

□ 相关含义

黄色是阳光下的笑脸和向日葵的色彩，通常被认为是暖色中最亮、最富活力的色彩。它与幸福和青春相关，充满希望和积极的象征意义，而男性通常将黄色视为一种无忧无虑，甚至是幼稚的色彩。因此，在对男性销售那些体现身份或价值昂贵的产品时，建议不要使用黄色（如黄色的西装或黄色的奔驰汽车）。

使用技巧：
• 使用鲜亮的黄色可以带来幸福和快乐的感觉。
• 比起蓝色或粉色，浅黄色更适合那些无性别倾向的婴幼儿产品用色。
• 极浅的黄色比起鲜艳的黄色更能给人以平静的幸福感，并且还带有聪颖、新鲜和愉悦的通感。
• 深黄色和金色带有些古典特质，可用于体现持久感的设计中。
• 黄色与黑色的组合是双色组合中最醒目的搭配，是常用的警示配色。

▌ Warm Colors include Red, Orange, Yellow, and Variations of Those Three Colors

Warm colors are the colors of fire, fall leaves, sunsets and sunrises, which are generally energizing, passionate, and positive. Red and yellow are both primary colors, with orange falling in the middle (making it a secondary color), which means warm colors are all truly warm and are not created by combining a warm color with a cool color.

▌ Yellow—optimistic, cheerful, playful, happy

Yellow is the color of the sun-life support for our planet. As such it has come to represent life, energy, happiness, hope, and wisdom. Vincent Van Gogh's 'Sunflowers' is painted almost entirely with yellow and without any shadows. It expresses the radiance of sunshine rather than giving us a detailed description of what the flowers look like. Van Gogh also uses yellow as the symbol of hope and friendship as the 'Sunflowers' series was painted to welcome his friend Paul Gauguin to the Yellow House in Arles.

□ Associated Meanings

Being the color of sunshine smiley faces and sunflowers, yellow is often considered the brightest and most energizing of the warm colors. It's associated with happiness and youth, full of hope and positivity. Men usually perceive yellow as a very lighthearted, 'childish' color, so it is not recommended to use yellow when selling prestigious, expensive products to men—nobody will buy a yellow business suit or a yellow Mercedes.

Tips for use in Design:
• Bright yellow can lend a sense of happiness and cheerfulness.
• Softer yellows are commonly used as a gender-neutral color for babies and young children (rather than blue or pink).
• Light yellows tend to disappear into white, giving a more calm feeling of happiness than bright yellows. It is associated with intellect, freshness, and joy.
• Dark yellows and gold-hued yellows can sometimes look antique and be used in designs where a sense of permanence is desired.
• Yellow is seen before other colors when placed against black, and this combination is often used to issue a warning in sign.

□ 情感效应

　　黄色是远距离注视中最显眼的颜色（道路标志中的常用色），同时也传达着快乐、友好、能量的情感寓意。如果想将品牌与速度、乐趣和低成本相关联，那么使用黄色是个不错的选择；黄色还与清晰的头脑和智力相关。另外，尽管不如红色强烈，但黄色标识也可以表达危险的信息。

　　这套便签信纸专为魔术师团队The Citrus Brothers设计。黄色就像魔术师一样，令人愉悦、有趣并引人发笑。

　　Martis Lupus设计的Why Bar的包装中使用的黄色调与品牌塑造的快乐、健康的形象十分贴切。

Citrus Brothers by Griselda Marti

Why Bar by Martis Lupus

　　黄色也经常用于体现速度和效率，就像法拉利标识中的黄色那样。

　　Unforked主要使用略深的黄色调，配合不同明暗的辅助黄色，使其外观既醒目又比较柔和。空间中的色彩搭配创造了有趣的图形，独特的视觉语言并塑造了品牌故事。

Unforked Environment

影响	趣味实例
• 刺激心理过程	• 在10世纪的法国，叛徒和罪犯的门被漆成黄色。
• 刺激神经系统	• 黄色在希腊文化中表示"悲伤"，在法国文化中表示"嫉妒"。
• 激活记忆	
• 促进交流	• 从心理学角度来说，黄色是光谱中最快乐的颜色。
	• 漫画人物绿灯侠害怕黄色。
	• 在美国销售的铅笔有75%被涂成黄色。

■ 橙色——新鲜、年轻、富有创造力、喜欢冒险

　　作为二次色，橙色拥有原色的基因：红色的创造和激情与黄色的能量和喜悦。美国抽象表现主义画家马克·罗斯科，鼓励观众靠近他的大型画作"橙色和黄色"，去体验色彩带来的精神层面的沉浸感。作品中，橙与黄打造出的"熊熊烈焰"，仿佛开启了通往原始和古老艺术的精神通道。

Mark Rothko
Orange and Yellow, 1956 (oil on canva

☐ Emotional Response

Yellow is the most visible color from a distance (which is why it is used for street signs) and communicates cheerfulness, friendliness, joy, and energy. Yellow is a great choice if speed, fun, and low cost are attributes you want to associate with your brand. It can also be associated with mental clarity and intellect. However, yellow is also associated with danger, though not as strongly as red.

This stationery is for the illusionist group The Citrus Brothers. The yellow, like the illusionists, is cheerful, entertaining, and smile-inducing.

This shade of yellow works well for a happy, healthy brand like Why Bar in this packaging by Martis Lupus.

When yellow comes to branding, yellow can be applied to signal a range of ideas. For example, it is often used to signal speed and efficiency, as seen in brands like Ferrari.

Unforked mainly uses a slightly darker yellow and various tones of yellow, giving it an eye-catching but slightly muted look. They created playful graphics, distinct language, and brand story integrate with space and color.

Effects	Facts
• Stimulates mental processes	• During the tenth century in France, the doors of traitors and
• Evokes the nervous system	criminals were painted yellow.
• Activates memory	• Yellow signifies 'sadness' in Greece's culture and 'jealousy' in
• Encourages communication	France's culture.
	• Yellow is psychologically the most pleasant color in the color
	spectrum.
	• The comic book character Green Lantern was afraid of the color
	yellow.
	• 75% of the pencils sold in the United States are painted yellow.

▦ Orange—fresh, youthful, creative, adventurous

As a secondary color, orange combines elements of the colors used to mix it: the creative passion of red with the energy and joy of yellow. Mark Ro thko, the American abstract expressionist artist, encouraged viewers to stand close to his large paintings so that they became spiritually immersed in the experience of color. 'Orange and Yellow' is the door to an inferno of color with radiant energy that invites the spectator to open their emotions to a spiritual kinship with 'primitive and archaic art'.

□ 相关含义

橙色融合了红色的温暖和黄色的乐观，展现出阳光和温暖的特质。它还是具有骄傲与雄心的色彩，像红色一样吸引着我们的注意力但却不像红色那样浓烈；它也常被用于具有警示作用的交通符号和服装中。暗调橙色经常与大地和秋季这样的季节变化相关，因此橙色通常也可以代表变化和运动。

□ 情感效应

由于橙色与富含维C的橙子在名称上的天然默契，它自然是一种充满能量、让人立刻联想到健康与活力的色彩。它是20世纪70年代美国的流行色，可以让人联想到年轻、创造力和冒险。橙色的情感效应有热情、吸引、幸福、决心、成功、鼓励、刺激等。

橙色也用于传达价格合理或低廉的产品，试想一下亚马逊和淘宝的品牌标志，以及它们如何使用橙色来暗示这一点。

使用技巧：
- *深橙色可以暗示欺骗与不信任。*
- *橙红色通常具有欲望、激情、愉悦、统治、侵略和渴望行动的意味。*
- *最好避免将橙色用于奢侈品、传统或历史悠久的品牌。*
- *适合年轻、充满活力的品牌，也非常适用于促销食品和玩具。*
- *橙色具有很高的可见度，利用这个特质突出设计中那些重要的元素。*
- *橙色一般比红色更友好，但不会像红色那样咄咄逼人，同样也能吸引注意力以及刺激行为。*

"Feeding the Self"是一个教导非洲青年通过种植蔬菜和药草来实现自我可持续发展的组织。橙色在这里传达着青春以及清新健康的感觉。

Feeding the Self by Lumo

"We Are Not Sisters"中深橙色、超尺寸的粗大字体充分利用了橙色的能量，立刻让观者接收到了橙色的内在含义，传递出一种年轻并充满活力的冒险感。

芬达的橙色就是利用充满活力的橙色来传递品牌的能量、热情和乐趣。

☐ Associated Meanings

Blending the warmth of red and the optimism of yellow, orange is the color of pride and ambition and is associated with sunshine and warmth. It attracts attention without being as daring as red and is used for warning signs like traffic cones and high-visibility clothing. In its muted forms, it is associated with the earth and with autumn. Because of its association with the changing seasons, orange can also represent change and movement in general.

☐ Emotional Response

Orange is a vibrant color that can bring to mind health and vitality, given its obvious link to oranges and vitamin C. It was certainly the color of the decade in the 1970s, and it can therefore tap into associations of youthfulness, creativity, and adventure. Orange also represents enthusiasm, fascination, happiness, determination, attraction, success, encouragement, and stimulation.

Orange is often used to communicate a product that is affordable and/or inexpensive. Think of the Amazon brand or Taobao logos and how they use orange to suggest this.

Tips for use in Design:
* *Dark orange can mean deceit and distrust.*
* *Red-orange corresponds to desire, sexual passion, pleasure, domination, aggression, and thirst for action.*
* *Best avoided for luxury, traditional or serious brands.*
* *Well suited to youthful, energetic brands and effective for promoting food products and toys.*
* *Orange has very high visibility and can catch attention and highlight the most important elements in the design.*
* *Orange commands attention without being as overpowering as red in the design. It's often considered more friendly and inviting for stimulates action and less in-your-face.*

'Feeding the Self' is an organization that teaches African youths to be self-sustainable with veggie and herb gardens. Here, orange conveys youthfulness, as well as the fresh and healthy feeling associated with gardens.

'We Are Not Sisters' dark orange, and oversized typography makes an immediate impact. Its bright and big bold typography takes full advantage of the energy that orange can convey a vibrant sense of adventure and youthfulness.

Alternatively, vibrant oranges are used to promote energy, enthusiasm, and fun. Think of Fanta's bright, enthusiastic use of the color.

影响	趣味实例
• 刺激行为	• 在"喜欢的颜色调查"中，橙色通常是得分最低的。
• 刺激食欲	• 橙色曾在美国总统建立的色彩编码安全警示系统中代
• 鼓励社会交往	表着较高的级别。
	• 橙色是美国陆军信号兵团的色彩。

▇ 红色——危险、激情、兴奋、能量

红色凭借火和血液一般的直观视觉联系，被用来表示
危险、愤怒和暴力。当它与内心的情感相连时，却可以表达
爱与激情。在保罗·高更的《雅各与天使搏斗》中，营造了精
神战场上与天使搏斗的幻象，这是对高更内心违背上帝旨
意的恰当隐喻。

Paul Gauguin
Jacob Wresting wih the Angle, 1888
(oil on canvas)

☐ 相关含义

红色是具有强烈感情的色彩，通常与能量、战争、危险
和力量联系在一起，也与激情、欲望和爱联系在一起；它还
能促发冲动购买行为，经常用来吸引消费者的注意力。在许
多亚洲国家(如印度和中国)，红色被视为欢乐、福祉和吉祥
的色彩。

☐ 情感效应

红色显然是一种大胆并且活力无穷的色彩，可以象征
强度、自信和力量。它可以营造多种情景，与标识结合使用
可显著提高视觉关注度，这也是停车标志、交通信号灯和消
防设备通常使用红色的原因；红色对人的生理也会产生影
响，令血压升高、呼吸频率增高等；红色还可能暗示着愤怒，
也与重要性相关联——想想颁奖晚会和名人活动中的红地
毯；红色也表示危险，警告标识通常为红色，例如消防车上
的字体和禁行标志等；红色也是一种会刺激食欲的色彩，因
此常见于可口可乐、麦当劳等连锁快餐企业中。

Effects	Facts
• Stimulates activity and appetite	• In the 'Favorite Color', orange usually comes the lowest.
• Commands attention	• Orange was the color that means 'high' in the color-coded
• Encourages socialization	threat system established by America presidential order.
	• Orange is the color of the United States Army Signal Corps.

▓ Red—danger, passion, excitement, energy

Through its association with fire and blood red is used to represent danger, anger, and violence. For the same reason, it is also associated with affairs of the heart: love and passion. In Paul Gauguin's 'Vision after the Sermon', Jacob wrestles with the angel in a blood-red field of spiritual battle, an apt metaphor for his internal struggle against the will of God.

☐ Associated Meanings

Red is an emotionally intense color, so it's often associated with energy, war, danger, and power and passion, desire, and love. It is supposed to prompt impulse buying and is often used to grab viewers' attention. In many Asian countries such as India and China, red is regarded as the color of happiness, wellbeing, and good fortune.

☐ Emotional Response

Red is a bold, energetic, and lively color that can symbolize strength, confidence, and power. It has several different contextual associations and in sign can deliver a highly visible punch, which is why stop signs, stoplights, and fire equipment are usually painted red. Red can actually have a physical effect on people, raising blood pressure, respiration rates and stimulate the appetite. Red can be associated with importance. Think about the red carpet at awards shows and celebrity events. It also indicates danger, like the bold red of a fireman's truck or the 'stop' sign in traffic, and that warning labels are often red. Red is also a color that is thought to stimulate appetites and hunger, which is why it's popular in fast food chains—Coca-Cola, McDonald's.

设计应用提示:
- *亮红色代表欢乐、性、热情、敏感和爱。*
- *粉红色表示浪漫、爱情和友谊,体现女性特质和顺从的含义。*
- *深红色有力而优雅,展现了活力、毅力、愤怒、渴望和领导气质。*
- *棕红色表示稳定,可以代表男性气质。*
- *设计中的红色可以作为强调色,并且可以令文本和图像更醒目。*

RED Development的购物袋设计中运用了夺目的红色,立即捕获了观者的注意。

RED Development

Kombi主要销售适合加拿大气候的冬季保暖服装。品牌中的红色不仅借鉴了加拿大国旗中的色彩,同时尝试唤起温暖、炽热的感觉。

Kombi brand identity, Image from Abduzeedo

瑞典民主青年联盟的视觉识别采用红色,因为它与政治紧密相关。在瑞典,红色代表着民主党的传统象征——红玫瑰。

SSU by Snask

红色还经常被用于传达充满创造力的电子或软件品牌,如Adobe、佳能和任天堂都是典型案例。

影响
- 提高激情
- 刺激能量并增强生理反应
 (血压、呼吸、心跳和脉搏率)
- 激励行为和自信

趣味实例
- 红色是彩虹中弧度最大的弧线。
- 红色是波长最长的可见光。
- 在风水学中,红色的前门会带来安居和繁荣。
- 蜜蜂无法辨识红色。

Tips for use in Design:
• *Light red represents joy, sexuality, passion, sensitivity, and love.*
• *Pink signifies romance, love, and friendship. It denotes feminine qualities and passiveness.*
• *Dark red is more powerful and elegant, associated with vigor, willpower, anger, longing and leadership.*
• *Brown suggests stability and denotes masculine qualities.*
• *Red can be a powerful accent color in design and bring text and images to the foreground.*

The striking red shopping-bag-inspired marketing piece instantly grabs clients' attention.

Kombi sells warm winter clothing suitable for the Canadian climate. Its brand identity uses red to evoke that feeling of warmth and heat and draw on the colors on the Canadian flag.

This visual identity the Swedish Democratic Youth League uses red as it is strongly tied to political affiliations. In Sweden, red is for the Democratic Party, derived from its traditional symbol of a red rose.

Red is also often seen being applied as a color to promote creativity in electronic/software brands. Adobe, Canon, Nintendo are all prime examples of this in action.

Effects
• Increases enthusiasm
• Stimulates energy and can increase a physiological reaction (blood pressure, respiration, heartbeat, pulse rate)
• Encourages action and confidence

Facts
• Red is the maximum arc of the rainbow.
• Red is the longest wavelength of visible light.
• Feng shui recommends painting the front door of a home red to invite prosperity to the residents.
• Bees cannot distinguish red or shades of red very well.

冷色系包括绿、蓝、紫，一般比暖色系更加柔和

如果你想要打造一个平和而沉静的环境，绿色或蓝色都是不错的选择。凉爽的冷色系是夜晚、水、自然的色彩，通常给人的感觉是平静、放松并有些矜持。而蓝色是冷色光谱中唯一的原色，这意味着其他大多数色彩都要通过蓝色和暖色混合而成。

绿色——自然、活力、威望、财富

"梅溪桥"运用了水平、垂直和对角线的构图形式，桥梁的曲线在某种程度上减弱了画面的严谨性。繁茂的绿色植物仿佛在庇护着这座坚固的建筑物，整个场景沐浴在神奇的翡翠般的光照下。绿色是植物和草地的颜色，是自然的色彩，代表了与健康和生长，为此，塞尚称他的画为"自然之后的建筑"。

Paul Cézanne
The Bridge at Maincy, 1879 (oil on canvas)

☐ 相关含义

绿色应该是人眼感受最舒服的色彩，它是大自然环境中的葱郁色，象征着增长、自然、更新、好运和金钱。对于某些人来说，它是让人放松的色彩，所以会在很多休闲和"禅意"的设计中看到它。但是，它有时也用于表示一些负面的寓意，例如嫉妒和缺乏经验。

☐ 情感效应

绿色作为"朴实"的色彩，不仅具有与蓝色相似的某些属性，也包含了一些黄色的基因。它一方面传达了对于生命和更新的向往，在环境、可持续、有机和自然的意义上传达"绿色"理念，另一方面绿色还暗示着金融与财富的效应。

◼ Cool colors include green, blue, and purple, are often more subdued than warm colors

Are you looking for a peaceful and calming environment? You might consider using green and/or blue. Cool colors are the colors of night, water, nature and are usually calming, relaxing, and somewhat reserved. Blue is the only primary color within the cool spectrum, which means the other colors are created by combining blue with a warm color.

◼ Green—natural, vitality, prestige, wealth

'The Bridge at Maincy' is a formal composition of horizontal, vertical, and diagonal lines whose rigor is somewhat relieved by the curves of the bridge. What turns this steadfast structure into a woodland sanctuary is the myriad of greens that bathe the scene in magical emerald light. Green, as the color of plants and grass, is the color of nature and all that is associated with health and growth. Paul Cézanne called his paintings 'constructions after nature'.

☐ Associated Meanings

This is the easiest color for the human eye to process. It's the verdant color of nature and the environment, and the symbolism is growth, nature, renewal, good luck, and money. It can also be a very relaxing color for some, which is why you'll see it used in a lot of leisure and 'zen-like' design.

☐ Emotional Response

As a down-to-earth color, green has two very common strong emotional correspondence that is quite paradoxical. One being nature and the environment, and the other being finance and wealth. When it comes to nature, green represents plant life and renewal and is consequently used to convey being 'green' in the environmental, sustainable, organic, natural sense of the word. Green has many of the same calming attributes that blue has, but it also incorporates some of the attributes of yellow.

设计应用提示：
• 暗绿色可以隐喻野心、贪婪和嫉妒。
• 黄绿色表示疾病、怯懦、无序与嫉妒。
• 水绿色指向情绪康复和保护。
• 橄榄绿代表和平，具有讽刺意味的是，它是军服中常见的颜色。
• 深绿色是美元的颜色，因此在美国意味着财富与稳定。
• 用于药品广告和医疗产品时，绿色代表安全。
• 绿色多用于推广有机或天然产品。

HelloMind的亮绿色背景体现了年轻和成长的意味，这与改善大脑功能的产品诉求一致。

HelloMind Website

Filmfaktisk的品牌标识使用朴实的松绿色，松绿色调与图形图像结合后的应用增强了品牌威望和设计的层次。

Filmfaktisk by Heydays

在这款有机竹制品包装中，绿色与天然材料完美地传递了绿色理念。

Packaging by Tomdesign.org

较饱满的暗绿色是最稳定且最富裕的代表。Knock经过重新定位Handsome形象识别中的图标和色彩，使它的视觉导向和样品展示方案吸引了更为广泛的受众。

Handsome Cycles

影响
• 舒缓情绪
• 放松身心
• 帮助减轻抑郁、神经质和焦虑
• 更新、自我控制与和谐

趣味实例
• 利比亚的满幅绿色国旗是目前唯一的单色国旗。
• 时装界有一种旧时迷信，认为在时装表演前夕用绿线缝纫会带来厄运。
• 绿色是夜视镜所采用的颜色，因为人类的视觉对绿色不同深浅的色调更为敏感且易于辨识。
• 1920年在加利福尼亚州比弗利山庄的一场车祸，导致NASCAR赛车手几十年来一直对绿色带有偏见。

Tips for use in Design:
- *Dark green is closely related to ambition, greed, and jealousy.*
- *Yellow-green can indicate sickness, cowardice, discord, and jealousy.*
- *Aqua is associated with emotional healing and protection.*
- *Olive green is more representative of peace and ironically a color common in military uniforms.*
- *The darker green is associated with money (US money) and so represents wealth and stability.*
- *Green is used to indicate safety when advertising drugs and medical products.*
- *Green is directly related to nature, so is used to promote 'green' or natural products.*

HelloMind's bright green background is youthful and gives a sense of growth, which in line with their product for improving your brain function.

Green is used to great effect for Filmfaktisk's branding identity. An earthy, pine green tint has been applied to various images adding a sense of prestige, richness.

The green works well with the natural material in this organic bamboo packaging by Tomdesign.org for Midori Way.

Darker, richer greens are the most stable and representative of affluence. Knock, designing a visual guide to filter communications and detail craftsmanship. The redeveloped Handsome identity collects classic iconography and color that appeals to a broad audience and pairs beautifully with their models.

Effects
- Soothes
- Relaxes mentally, as well as physically
- Helps alleviate depression, nervousness, and anxiety
- Offers a sense of renewal, self-control, and harmony

Facts
- The solid green flag of Libya is currently the only national flag of a single color.
- There is an old-time superstition in a fashion that says sewing with green thread on the eve of a fashion show it will bring bad luck.
- Green is the color used for night-vision goggles because the human eye can distinguish more shades of green than any other color.
- NASCAR racers have shared a bias against the color green for decades because of a 1920 accident in Beverly Hills, California.

■ 蓝色——交流、可信、镇定、沮丧

在古典神话中,蓝色是与神、维纳斯和木星相关的色彩;在基督教中,它是圣母玛利亚升天的象征。蓝色静谧感在惠斯勒的《夜曲》中得到了充分的体现,这种风格受到日本"浮世绘"艺术的强烈影响。

□ 相关含义

作为天空的色彩,蓝色与平静和安全感相关联;作为海洋的色彩,也暗示着新鲜、纯净和卫生等品质。蓝色是一种舒缓而宁静的色彩,代表着智慧和责任感。

James Abbott Mcneill Whistler
Nocturne, Blue and Silver: Chelsea,
1871 (oil on wood)

□ 情感效应

有研究表明,它可以降低心率、促进放松并提高生产力。它是值得信赖的公司与机构的首选色彩,蓝色也是社交媒体网站(脸书、推特和支付宝)的首选色,借此传达可靠性、信任力和沟通力,并能够表达机构的权威性和可靠性(IBM、Visa、中国建设银行)。当蓝色与情感联系在一起时,英语中代表着悲伤或沮丧。

设计应用提示:
- *蓝色中深浅色调的细微差别会带来设计中感知方式的巨大差异。*
- *浅蓝色隐喻着健康、治愈、安宁、理解和柔软。*
- *亮蓝色应用于活力与清爽。*
- *深蓝色传达知识、力量、正直和严肃感,对看重实力和信任度的公司网站或设计来说非常适合。*

Porto by White Studio

White工作室使用了波尔图的城市彩色和瓷砖图案中的蓝色,设计了全新的视觉识别系统,来传达城市的故事。

使用了具有专业精神、可信度和力量感的蓝色使Siegfried充满了现代感。

Siegfried by Skinn

■ Blue—communicative, trustworthy, calming, depressed

In classical mythology, blue was the color associated with the gods, Venus and Jupiter. In Christianity, it becomes the symbol of the Virgin Mary as Queen of Heaven. The calmness of blue is seldom more visible than in this 'nocturne' of the River Thames by Whistler, which is strongly influenced by the Japanese art of 'ukiyo-e'.

□ Associated Meanings

As the color of the sky, blue is associated with calmness and security. As the color of the ocean also suggests qualities like freshness, purity, and hygiene. Blue is a serene and calming color that represents intelligence and responsibility.

□ Emotional Response

Blue has been documented to lower heart-rate, foster relaxation, and increase productivity. It's the go-to color for trusted corporate institutions, often combined with social media sites that wish to convey reliability, trustworthiness, communication (Facebook, Twitter, and Alipay), and express the authority and dependability of organizations (IBM, Visa, China Construction Bank). However, being associated with the emotional feeling of being 'blue' is also used to express sadness or depression in the English language.

Tips for use in Design:
* *The exact shade of blue you select will have a huge impact on how your designs are perceived.*
* *Light blue is associated with health, healing, tranquility, understanding, and softness.*
* *Bright blue can be energizing and refreshing.*
* *Dark blue represents knowledge, power, integrity and seriousness, and is excellent for corporate sites or designs where strength and reliability are important.*

White Studio designed a new visual identity system for the city of Porto. They used the blue from the city's colored and patterned tiles and used it to communicate stories of the city.

Blue conveys Siegfried's professionalism, dependability and strength, while the vibrancy of the blue is contemporary.

Made Smart在全区的
广告系列中使用亮蓝色作
为主要色彩。

Made Smart — Center School District

影响	趣味实例
• 平静和安宁	• 在 "喜欢的颜色调查" 中，男性和女性最喜欢的颜色
• 头脑冷静	都是蓝色，其次是绿色。
• 引起抑郁	• 研究表明人们在蓝色的房间里会有更高的生产力。
	• 蚊子被蓝色吸引的概率是其他色彩的两倍。
	• 毕加索在 "蓝色时期" 创作的画作表现得如此孤独、
	悲伤或失落。

■ 紫色——王权、威严、灵性、神秘

这是一版20世纪50年代英国皇家邮政的紫色邮票，
由Wildings公司发行，邮票上印有英国女王伊丽莎白二
世的肖像。在伊丽莎白一世统治时期规定只有她和王室
成员才能穿紫色，紫色现今仍然被英国皇室使用。

□ 相关含义

很久以前紫色仅供皇室成员和统治者使用，部分原
因是因为这种染料非常稀有，由于紫色与皇室联系在一
起，所以令它更加具有尊贵和奢华的气质，即使后来紫
色布料变得平民化了，它依然是财富和地位的象征。

□ 情感效应

紫色是红色和蓝色的结合，兼具蓝色的稳定性和红
色的能量感。紫色传达出一种灵性，如果是暗调紫，会带
有威严和尊贵的感觉；另外，它还与创造力和想象力相
关，研究表明紫色可以激发大脑解决问题，它均衡了红
和蓝两者的特质，寻求"刺激"和"平静"间的平衡来促生
创造力。

The Postal Museum

Made Smart uses a bright blue as the primary color on the district-wide Made Smart campaign.

Effects
• Calls calmness and serenity
• Maintains cool
• Evokes melancholy

Facts
• In the 'Favorite Color', the top choice for both men and women was the color blue, with green as the overall second best.
• Research has shown that people are more productive in blue rooms.
• Mosquitos are attracted to the color blue twice as much as to any other color.
• Paintings produced by Picasso during his 'blue period', can seem so lonely, sad, or forlorn.

■ Purple—royalty, majesty, spiritual, mysterious

In the 1950s, the British Royal Mail violet postage stamps were issued by the Wildings with a portrait of Queen Elizabeth II. Queen Elizabeth ruled she and royal family members could wear purple. It is still a color used by the British royal family.

☐ Associated Meanings

In ancient civilizations, the purple color was reserved for royalty and leaders, in part because the dye was so rare. Because of its associations with royalty, purple is inherently prestigious and luxurious. Even when purple clothing became more familiar it remained a symbol of wealth and affluence.

☐ Emotional Response

Purple is a combination of red and blue and takes on some attributes of both, which combines the stability of blue and the energy of red. Purple conveys a sense of spirituality and, if darkened, majesty and royalty. It's also associated with creativity and imagination. Studies have shown that the color purple actually stimulates the problem solved in the human brain. It utilizes both red and blue to provide a nice balance between stimulation and serenity to encourage creativity.

设计应用提示：
• 浅紫色可以用于怀旧设计。
• 明亮鲜艳的紫色有助于宣传儿童产品。
• 暗紫色通常代表奢侈或尊贵，但也可能让人感到忧郁和悲伤。
• 紫色最适合用于女性受众，因为研究表明，女性将紫色列为顶级色彩。

Moniker为医疗软件公司Tidepool设计的名片。深紫色在中色调蓝色和白色的衬托下显得饱满而庄严。

Tidepool by Moniker

紫色通常利用其与皇室的历史渊源，象征着奢侈、昂贵、高品质，就像威士忌品牌Crown Royal。

在迪士尼/皮克斯出品的《玩具总动员3》中，可爱的玩具多莉有着紫色的头发，她的角色是邦妮·安德森玩具公司的负责人。

Disney / Pixar's Toy Story 3

影响
• 振奋身心
• 镇静情绪和神经
• 提供一种灵性感
• 鼓励创造力

趣味实例
• 紫色是扑克筹码最高面值的颜色=5000美元。
• 紫色代表木星。
• 在日本，紫色象征财富和地位。
• 紫色是眼睛最难分辨的颜色。
• 胡萝卜除了常见的橙色，还有红色、白色、黄色和紫色的。

● 中性色系包括棕色、黑色、灰色及更多色彩

中性色是一种饱和度极低或者说是缺乏显著色彩感的颜色，对那些鲜亮的色彩和图形来说，中性色是一个很好的背景色。它们虽然不是传统色相环中的色彩，却常带有一定的色彩意味或倾向。选择时，应该考虑到与其他色彩搭配过程中对中性色的影响。也就是说，中性色无论在寓意还是色彩表现方面都比冷暖色受周围环境色的影响更大。

Tips for use in Design:
* *Light purples can be used in a nostalgic design.*
* *Bright purple is good for promoting children's products.*
* *Dark purple often represents luxury or opulence but can evoke gloom and sad feelings.*
* *Purple is best used for targeting a female audience as research suggests that while women list purple as a top-tier color.*

Business cards for medical software company Tidepool. The deep purple (contrasted with mid-blue and white) is rich and majestic.

Purple usually draw on the historical ties of the color with royalty to help build a luxurious, expensive, high-quality brand, such as the luxe whiskey brand Crown Royal.

Dolly, the sassy, purple-haired pal from Disney / Pixar's Toy Story 3, is the leader of Bonnie Anderson's toys.

Effects	Facts
• Uplifts	• Purple is the color of the highest denomination poker chip = $5,000.
• Calms the mind and nerves	• Purple represents the planet Jupiter.
• Offers a sense of spirituality	• In Japan, the color purple signifies wealth and position.
• Encourages creativity	• Purple is the hardest color for the eye to distinguish.
	• Carrots used to be purple—as well as red, white, yellow, and orange.

Neutral colors include brown, black, grey, and more

A neutral is a color without much saturation—a color that's lacking in intensity. For that reason, neutrals are a great backdrop for pops of bold colors and patterns, simply because they do not compete with them. Neutrals are not on the color wheel, but they certainly have undertones of colors from the color wheel, and you should take those tints and tones into account when choosing a neutral. The meanings and impressions of neutral colors are much more affected by the colors that surround them than are warm and cool colors.

■ 棕色——有机、健康、简单、诚实

灵性的色彩是文森特·凡·高绘画的个人标识,尽管这幅画是他的后期作品,但文森特·凡·高仍使用了早期作品的暗棕色调来反映主题的谦逊,画中描绘了一双普通农民的破旧皮鞋。棕色亲近自然,是大地、木材和石头的色彩。他用粗犷的土褐色入笔,暗示出主人生活的艰辛,也向体力劳动者的尊严表达了敬意。

Vincent van Gogh
Shoes, 1888 (oil on canvas)

□ 相关含义

我们在木材、石材的纹理中都会发现棕色,它是一种发暖的中性自然色。棕色具有稳定感和支撑感,因此常被用来代表一种谦卑的美德。与棕色相关的常见含义有:深度、粗糙、丰富、简单、严肃、微妙、实用等。

□ 情感效应

棕色带有健康、有序和亲近自然的感觉,用它来表达结实、耐用与可靠时,此类品牌立意会胜过某些多色表达,它引导人们更关注品牌价值的深层含义。在这个倡导有机、天然的食品和美容品的时代中棕色被广泛的使用;我们也可以使用棕色去体现传统感,用于表现历史悠久的文化遗产;当然,棕色也是最适合巧克力产品的用色。

设计应用提示:
• 浅棕色是友好、热情、诚实、恳切和纯真的。
• 强有力的深褐色可以代替背景或排版中的黑色。
• 棕色唤起人们对手工艺和户外运动的探索兴趣。
• 将棕色与绿色搭配使用,可准确地表达有机的感觉。
• 棕色有时会给人有点"脏"的感觉,要小心使用。

这个炸鱼薯条的视觉识别概念将各种色调的棕和无涂层纸结合在一起,传达出健康、天然、有机食品的感觉。

Everybody Loves Fish & Chips

Brown—organic, wholesome, simple, honest

Although this painting is from Vincent Van Gogh's later body of work noted for the brilliance of its color, he reverts to the darker brown tones of his earlier work to reflect the humility of the subject matter. These are the tired old shoes of a humble peasant. Brown is a natural color associated with the earth, wood, and stone. Van Gogh paints this image in rugged earthy browns to suggest the hardship of their owner's life and to pay respect to the dignity of manual labor.

☐ Associated Meanings

Brown is seen in wood textures and sometimes in stone textures, so it is a warm neutra and completely natural color. It is also used to represent humility: a down-to-earth virtue, and as a result giving a sense of stability and support. Common associations with brown include depth, roughness, richness, simplicity, seriousness, subtlety, and utility.

☐ Emotional Response

It is strong, durable, and honest and may express that brand has better things to care about than superfluous color. Brown gets a lot of use in this era of organic and natural food, beauty, and products. We can also use it to give the impression of a well-established heritage and a sense of tradition. Brown works well for chocolate brands, for obvious reasons.

Tips for use in Design:
* *Light brown is friendly, welcoming, honest, sincere, and genuine.*
* *Dark brown is strong, used in its darkest forms as a replacement for black, either in backgrounds or typography design.*
* *Brown evokes craftsmanship and the great outdoors.*
* *Use brown for an earthy brand and in a natural pairing with green to capture that organic feel.*
* *Use caution with brown as it can remind people of dirt.*

This concept visual identity of unites various tones of brown and uncoated paper to convey a sense of wholesome, natural, organic food.

Brand identity for United Soil by Studio Otwarte

　　波兰设计机构Studio Otwarte为United Soil设计的品牌标识中,设计师使用了明亮的原色,为棕色包装带来了小巧而有冲击力的强调色,同时也在棕色纸包装的自然质感和原色的现代感之间达到了平衡。

　　深沉而饱满的棕褐色通常用于发出高品质和豪华风格的讯号。典型的例子是路易威登的标志性棕色。

⬤ 黑色——优雅、正式、力量、豪华、悲伤

　　黑色特有的黑暗属性常被用来表现死亡和哀悼等主题,凯绥·柯勒惠支创作的木刻作品《寡妇》是Kreig(战争)系列作品中的一幅,该作品描绘了第一次世界大战的人间悲剧,一个伤心欲绝的妻子怀念着她去世的丈夫的悲凉形象。黑色非常贴切此类悲伤和令人痛苦的主题。

□ 相关含义

　　黑色是明度最低的颜色,它暗含着死亡、邪恶、巫术、哀悼以及对未知的恐惧。在纹章学中,黑色是悲伤的象征,通常带有负面含义,如黑名单、黑色幽默、黑死病等。

Käthe Kollwitz
The Widow, 1922-1923 (woodcut)

□ 情感效应

　　尽管黑色有着死亡、恐惧和悲伤等负面寓意,但在品牌和营销方面,它通常又与力量和优雅联系在一起,与不同的色彩组合后它变得可保守可现代,既能体现传统的经典感,又可别具一格。鲜艳的色彩虽然可以快速提高品牌辨识度,但对黑色的恰当使用可以传达出与众不同、令人难忘的品牌属性,如黑白的搭配就是香奈儿和迪奥的标志性配色。

A Design Film Festival by Anonymous on Behance

In this brand identity design for United Soil by Polish design agency Studio Otwarte, the designers use a bright pop of primary color to create a small, impactful accent against otherwise brown packaging. This successfully balances the natural feel of the brown paper packets with a more contemporary edge.

Deep, rich browns are often applied to signal high quality and luxe style. One of these is Louis Vuitton's signature brown.

Black—elegance, formal, power, luxurious, sorrowful

Black and its association with darkness being used to represent death and mourning. 'The Widow' by Käthe Kollwitz is one of a series of prints from a portfolio called Kreig (War), which deals with the wretched human tragedy of World War I. This is a desolate image of a grief-stricken wife who is embracing the memory of her departed husband. Black is a very appropriate color for such a sad and distressing subject.

☐ Associated Meanings

Black is the ultimate darkest color. It is a mysterious color associated with death, evil, witchcraft, and the unknown fear. In heraldry, black is the symbol of grief, usually with negative connotations (blacklist, black humor, 'black death').

☐ Emotional Response

Although black can have negative connotations—it's the color of death, fear, and grief—it's more generally associated with power and elegance when it comes to branding and marketing. It can be either conservative or modern, traditional or unconventional, depending on the colors it's combined with. While color is more likely to increase brand recognition, there's no reason black—when used appropriately—can't be just as distinctive, memorable, and communicative of a brand's attributes, such as Chanel and Dior with an iconic black-and-white logo.

设计应用提示：
• 黑色作为设计中典型的中性色，常用于文本、排版等基础功能。
• 当黑色与其他明亮而有力的颜色，如红色或橙色搭配使用时，它会变成有影响力的色彩，甚至具有攻击性。
• 简单的黑白配色方案可以较好地传达引领潮流的专属感和渴望感。
• 以黑色为强调色的极简主义设计风格，具有非常现代的感觉。

亚光黑色和亮面黑色类型在A Design Film Festival的视觉形象中十分精致和独特。用色经典而大胆，质地和光泽引人注目。

Corvino Supper Club & Tasting Room

Corvino（乌鸦）这个名字隐喻的黑色是其调色板、肌理效果和材料的灵感来源，品牌用色显示了好奇心与创造性。

Wine crest (coat of arms) and label design

Dan Newman设计的黑和橙的葡萄酒标签醒目地传达了独特和奢华感。

影响	趣味实例
• 保持低调	• 伦敦街头的出租车一般都是黑色的。
• 侘寂	• 在古埃及，黑色代表生命和重生。
• 神秘	• 黑色具有重量感，人们会认为黑色盒子比白色盒子重。
	• 穿黑色更显瘦。

■ 白色——纯洁、朴素、无邪、极简主义

白色，因其与光的联系被用来代表平和、纯洁和善良。1915年，俄国艺术家卡兹米尔·马列维奇开创了几何化的抽象艺术风格，称之为"至上主义"。他认为纯粹的抽象形式具有精神力量，没有比白色更适合的色彩用来表达"绝对的至高无上"。

Kazimir Malevich
Suprematist Composition: White on White
1918 (oil on canvas)

Tips for use in Design:
• Black is an inherently neutral color in design, and is often used for text, typography, and other functional elements.
• When black combined with other bright and powerful colors like red or orange it can be quite impactful, even aggressive.
• When conveying a sense of exclusive and aspirational in edgier designs, a simple black-and-white color scheme is a good choice.
• Minimal design with black used as an accent color gives a design a super modern feeling.

Matte black with glossy black type is sophisticated and distinctive in this visual identity for the A Design Film Festival. It's classic, bold and the textures and shine are eye-catching.

The name Corvino, which means raven, provided the inspiration behind the color palette, textures, and materials. The color of the back presents the curious, inventive.

A striking, bright orange and black wine label design by Dan Newman convey a sense of exclusive and luxury.

Effects
• Keeps inconspicuous
• Offers restful emptiness
• Mysterious

Facts
• Taxi cabs are traditionally black in London.
• In ancient Egypt, black represented life and rebirth.
• Black is associated with weight, people will think a black box weighs more than a white one.
• Black is often used in fashion because of its slimming quality.

▣ White—purity, simplicity, innocence, minimalism

White and its association with light being used to represent peace, purity, and goodness. In 1915, the Russian artist Kazimir Malevich developed a geometric style of abstract art called Suprematism. He believed that pure abstract form had a spiritual power with an ability to open the mind to 'the supremacy of pure feeling', and there was no purer color for that purpose than white.

❑ 相关含义

白色可以传达的积极含义包括纯洁、干净、清晰、简洁和清新，它也被视为是精致的、流线的和高效的色彩，这些含义可能部分归功于"苹果"在其品牌中使用的白色。就消极方面而言，白色可能看起来生硬、冷漠、孤立。想想看，一个偌大的、白色的、空荡荡的房间可能会显得多么乏味和呆板。

❑ 情感效应

白色与黑色分别在光谱的两端，与黑色一样非常适合与其他色彩一起搭配使用。它可以说是所有色彩中最中性的，它的"平淡无奇"衬托了其他颜色的精彩。它是一张干净的白纸，象征着一个新的开始。

Hånvaerk by Savvy Studio

设计应用提示：
* *白色是视觉与心理上最浅的色彩。*
* *最适合让视线留有"呼吸"的空间。*
* *"留白"在设计中与所有其他创意元素一样重要。*
* *白色通常被设计师用来传达极简主义美学。*

Hånvaerk品牌通过白色来倡导精致、简约、利落的线条和低调的奢华。

Packaging design by Imee008

Imee008设计的白色包装让物品简单、干净，加上黑色后变得更加经典而简约。

苹果的标志、广告和包装都有力地说明了白色作为现代简约美学的代表色，将产品推上了中心舞台。

Apple's logo

影响	趣味实例
• 有助于头脑清晰	• 在战争中，白色意味着投降。
• 净化思想或行为	• 据潘通公司的研究，白色是经典T恤衫最畅销的色彩。
• 开启新的起点	• 白色调的商品远多于其他颜色的商品。
	• 在西方文化中，白色常与婚礼、医院和天使联系在一起。
	• 在东方文化中，白色大多象征着死亡和悲伤。

□ Associated Meanings

Some of the positive meanings that white can convey purity, cleanliness, clarity, simplicity, and freshness are also seen as sophisticated, streamlined, and efficient. This association is likely in part thanks to Apple's prolific use of white throughout their branding. On the negative side, white can seem stark, cold, and isolated. Consider how a large, white, empty room might seem tedious, bland, and stark.

□ Emotional Response

White is at the opposite end of the spectrum from black, but like black, it can work well with just about any other color. It's also the most neutral color of all and can be quite non-descript as a base for other, more exciting colors. The color white often seems like a blank slate, symbolizing a new beginning or a fresh start.

Tips for use in Design:
* *White is the lightest color both visually and in psychological weight.*
* *White gives a light feel to design work, and flow for the viewer's eye to move around.*
* *White space can be as important in a design as all the other creative elements.*
* *White is often used by designers to convey a minimalist aesthetic.*

The Håndvaerk brand promotes refined simplicity, clean lines, and understated luxury. It is all communicated through white-on-white.

This white packaging design by Imee008 keeps things very clean and simple and combined with simple black. It becomes classic and minimalistic.

Apple's logo, advertising, and packaging give a powerful illustration of how white can be used for a modern and minimalist aesthetic that puts the beautiful product design center stage.

Effects	Facts
• Aids mental clarity	• A white flag is universally recognized as a symbol of surrender.
• Evokes purification of thoughts or actions	• According to Pantone, white is the best-selling color for the classic T-shirt.
	• More shades of white are available commercially than any other color.
• Enables fresh beginnings	• In Western cultures, the color white is often associated with weddings, hospitals, and angels.
	• In many Eastern cultures, white is a symbolic link to death and sadness.

■ 灰色——强度、坚固性、寿命、仪式、专业性

帕勃罗·毕加索经常用单色绘画来增强作品的情感基调,他似乎把灰色调(纯灰色绘画)留给了他对死亡和压迫的描绘,像《格尔尼卡》(1937)、《骸尸所》(约1944-1948)、《朝鲜的屠杀》(1951)和这张《山羊头骨、瓶子和蜡烛》(1952)。

Pablo Picasso
Goat Skull, Bottle, and Candle, 1952
(oil on canvas)

□ 相关含义

灰色是一种坚实、永恒的颜色,传达着力量、坚固和长寿的含义,这些含义的产生可能与灰色物体的特质有关,比如钢铁、混凝土、石头。灰色的积极含义包括形式感和可靠性,而消极方面则意味着过于保守、传统和缺乏情感。

□ 情感效应

灰色是一种中性并"缺乏感情"的色彩,通常位于色谱上的冷色端。灰色也是一种非常复杂的色彩,它可以像老年人的灰白色头发透露出成熟和责任感,也可以表现喜怒无常或令人沮丧;它可以传达保守和正式,也可以代表现代与时尚;灰色也常应用于企业识别设计中,用以塑造形式意味和表达专业性。

Carthage Stoneworks Website

设计应用提示:
• 注意正确地使用灰色的不同色调, 否则灰色会对与它搭配使用的色彩产生衰减效果。
• 使用深灰色代替黑色文本时, 可以改变视觉上过强的对比度, 从而更易阅读; 浅灰色也是一样, 可以用来代替白色。
• 深灰色严肃、庄重且不灵活, 代表着自制和自律。
• 灰色与蓝色的搭配可以表达不过分保守又体现踏实可靠。

灰色是插图网站中理想的背景色,继承传统的现代手段恰恰是这家Carthage Stoneworks公司从激烈的竞争中胜出的原因。

当与现代字体混合使用,Lundqvist & Dallyn的灰色背景呈现出现代的感觉。

Lundqvist & Dallyn

⬛ Grey—strength, sturdiness, longevity, formality, and professionalism

Pablo Picasso often painted in monochrome to heighten the emotional tone of his work. He seems to reserve painting in grey tones (grisaille) for his images of death and oppression: 'Guernica'(1937), 'The Charnel House'(c.1944−1948), the Goya inspired 'Massacre in Korea'(1951) and 'Goat Skull, Bottle and Candle' (1952) .

□ Associated Meanings

The color grey is a solid, timeless color that communicates strength, sturdiness, and longevity. Likely because grey things have the exact attributes: steel, concrete, stone. Positive connotations include formality and dependability, while the negative side can mean being overly conservative, conventional, and lacking in emotion. It's safe and quite subdued, serious, and reserved.

□ Emotional Response

Grey is a neutral and unemotional color, generally considered on the cool end of the color spectrum. Grey can also be a very sophisticated color. It is also a more mature, responsible color associated with the grey hair of old age, or it can sometimes be considered moody or depressing. Grey is generally conservative and formal but can also be modern. Grey is commonly used in corporate identity designs, where formality and professionalism are essential.

Tips for use in Design:
* *Unless the precise tone is right, grey has a dampening effect on other colors used with it.*
* *Using dark grey as an alternative to black text for a less harsh contrast and an easier read. The same applies to light grey, which can be used in place of white.*
* *Dark grey is serious, solemn and inflexible, so it is associated with self-denial and self-discipline.*
* *Combine grey with blue for the ultimate in conservatism and dependability.*

Grey is a perfect background color for a site of illustrations. A modern spin on tradition is precisely what this company needed to stand out from its stodgy competition.

When mixed with modern typography, grey in Lundqvist & Dallyn as the background presents a modern feel.

"Lee"牛仔品牌通过使用复古墙纸、原始蚀刻、手写字体和现代灰色，展示了"Lee"牛仔作为精品牛仔服饰的概念，重新诠释了这一拥有悠久历史的品牌。

除了现代和正式，又具有些不寻常特征的灰和黑色的解构形式，构成了Mila Jones Cann的网站设计。

Lee Jeans The Voyage

影响	趣味实例
• 害怕接触	• 纽约时报偶尔被称为"灰色女士"。
• 创造期望	• 人类大脑由"灰质"组成。
	• 灰色是悲观主义的代表色。
	• 人眼可以分辨出约500种灰度。
	• 生活并非都是非黑即白。

Web design by Mila Jones Cann

■ 米色和棕褐色——活力、沉稳、力量、优雅

❏ 相关含义

米色有时会被描述为淡浅棕色或棕褐色，它蕴含了棕色的温暖和白色的清爽。与米色和棕褐色相关的寓意会根据其搭配的色彩而变化。传统上，它们被视为一种保守的背景色，但是它们又具有智力、智慧、思想和知性的象征意味。

❏ 情感效应

米色在色谱中有着自己的独特性，它会受周围色彩的影响呈现出或冷或暖的色调。大多数情况下，米色和棕褐色也带有温暖与安全感，它们会带有与棕色系色彩同样朴实的稳定感，虽然它们是一种令人放松的色彩，但也常被认为带有枯燥和乏味的意味。

设计应用提示：
• 经常与米色互换使用的其他色彩包括卡其色、浅黄色、象牙色、灰白色和沙漠色。
• 由于米色和浅棕褐色明度高且色彩感不强，因此平面设计师常把它作为背景色。
• 足够深的米色调可以应用于文本。
• 米色和棕褐色看起来是现代、时尚和都市的色彩。

Fully communicating the concept using vintage wallpaper, original etchings, handwritten typography, and modern grey showcased how the historic products were reinterpreted for the high-end boutiques of Lee Jeans.

A modern and formal design, but a little unconventional in this case, a grey and black deconstructed and unconventional web design by Mila Jones Cann.

Effects	Facts
• Fears of exposure	• The New York Times is sometimes called 'Grey Lady'.
• Creates expectations	• The human brain is composed of 'grey matter'.
	• Grey is the representative color of pessimism.
	• The human eye can distinguish about 500 shades of grey.
	• Life is certainly not all black and white.

■ Beige and Tan—energy, calm, strength, elegance

☐ Associated Meanings

Beige is described as a pale light brown color or a grayish tan with a bit of the warmth of brown and the crisp coolness of white. The attributes and meanings associated with beige and tan change based on the colors it accompanies. They have traditionally been seen as a conservative background color. On the other hand, the symbolism of them refers to intellectual abilities, wisdom, ideas, and knowledge.

☐ Emotional Response

Beige and tan are somewhat unique in the color spectrum, as they can take on cool or warm tones depending on the colors surrounding them. Like other browns, they evoke warmth and security. Most often, they also give a sense of the same earthy stability that many members of the brown family do. While they are all relaxing colors, beige and tan are often seen as dull and bland colors.

Tips for use in Design:
• Other colors often used interchangeably with beige include khaki, buff, ivory, off-white and desert sand.
• Because most beige and tan colors are very light, graphic artists tend to use them as background colors.
• A few beige shades are dark enough to use for text.
• Beige and tan can be colors that look modern, fashionable, and urbane.

Plane网站的温暖的褐色背景让人感觉既现代又不失简约。

Mile Inn网站将现代印刷版式与米色和黑色结合在一起,给网站带来既复古又时尚的气息。

Plane Site Design

The Mile Inn site

Finefolk工作室使用了丰富的金褐色,尤其是与醒目的字体结合使用给人一种高档的感觉。Design Ranch在春季时装展上发出了邀请,强调了商店的风格和品牌理念。

影响	趣味实例
• 轻松 • 呆板或无趣	• 由于第一批计算机是米色的,在消费类计算机产品中,米色盒子是标准的个人电脑。 • 纸张和画布纹理的背景中常见到米色和棕褐色。 • 宇宙的颜色不是绿松石色,而是被称作"宇宙拿铁"的米色(索引代码:#FFF8E7)。

Finefolk Studio + Shop by Ranch

■ 象牙色和乳白色——可靠、保守、灵活、运动

□ 相关含义

乳白色、珍珠色、灰白色和蛋白色是象牙色的同义词,或者说是不同明暗的象牙色。这种以大象和海象的牙齿命名的灰白色调,自14世纪就开始使用。乳白色和象牙色很相似,也是具有中性、镇定和放松的色彩,在艺术创作中通常被用作肤色。

□ 情感效应

作为中性色,象牙色和乳白色是精致的色彩,用于诠释安静和愉悦。象牙色比乳白色更能体现出低调的优雅,它们特别适合为低调的优雅定下基调,是婚礼请柬和雅致的个人文具的理想选择。象牙色比乳白色更具有低调优雅的轻松基调,而乳白色则更加丰富和温暖,两者通常都能唤起历史感。

Poster design by Ye Li

Plane Site's warm tan background color feels modern without feeling minimalist.

The Mile Inn site combines modern typography with a beige and black color palette for a site that feels retro and hip.

Finefolk Studio+Shop uses a more gold shade of tan, giving the site an upscale feel, especially when combined with bold typography. Design Ranch created a unique invitation for their spring fashion show, highlighting the shop's style and brand.

Effects	Facts
• Relaxation	• In consumer computer products, because the first computers
• Create dull and boring	were beige, a beige box is a standard personal computer (PC).
	• Beige and tan colors are commonly seen in backgrounds with
	paper and canvas texture.
	• The color of the universe was not Turquoise but a Beige color
	called 'Cosmic Latte' (Hexadecimal: #FFF8E7).

■ Ivory and Cream—dependable, conservative, flexible, sportive

☐ Associated Meanings

Milk white, pearl, off-white, and opaline are synonymous with ivory or represent various shades of the color ivory. This shade of off-white earns name from the tusks and teeth of elephants and walruses has been used since the 1300s. It's very similar to ivory. The cream is a neutral, calm, and relaxing color and is often used as a base for skin tones in art.

☐ Emotional Response

As neutral colors, ivory and cream colors are sophisticated colors and represent quiet and pleasantness. They are especially suited to set a tone of understated elegance. Ideal for formal wedding invitations and for elegant, personal stationery. Ivory sets a more relaxed tone of understated elegance than cream, while the cream is slightly richer and a touch warmer. Both of them can often evoke a sense of history.

设计应用提示:

- *像白色和灰色一样,象牙色和乳白色可以在设计元素间起到平衡的作用。*
- *像米色和棕褐色一样,象牙色和乳白色容易受到周围颜色的影响而具有周围色彩的特征。*
- *象牙色和乳白色也可以代替白色用于调和后提亮色彩的明度。*

Hall Family Foundation Annual Report by Design Ranch

Design Ranch使用了精致的肖像和静物摄影,配以简单的象牙色,在整个报告中都体现了"回归基础"的学校主题。

浓郁的乳白色与黑色背景一起搭配时,感觉是一种现代且前卫的强调色。

Sainte Paix Website Design

影响	趣味实例
• 多用途	• ivory dome一词的意思是"书呆子"。
• 安静而平和	• "象牙塔"一词是典型的与世隔绝的地方(比如"大学"),有时用来形容脱离现实的人。

◼ 金属色系包括金色、银色、铜色,象征了财富、繁荣、成功

▢ 相关含义

　　黄金和白银都是贵重金属,它们是财富的象征。金色带有黄色的属性,也是所有色彩中最具物质性的,象征着富足与奢华;银色也是一种专色,带有平滑的金属光泽,同时兼具一些灰色的寓意;铜色具有棕色的特性,相比金银两色它更加朴实、自然和成熟。

Gazing Ball (Farnese Hercules) by Jeff Koons, photo by Yongxin Hang

Design Ranch used captivating portrait and still life photography, paired with simple, smart ivory color to carry the 'back to basics' school theme throughout the report.

Rich cream feels like a very modern and even edgy accent color when used with a black background.

Effect	Facts
• Versatility	• The term 'ivory dome' refers to somebody as a bookworm.
• Quiet and peace	• The phrase 'ivory tower' is typically a place of refuge or seclusion from the world (Institutions of higher learning). Sometimes used to describe someone who is out of touch with reality.

> 在视觉社会中，了解如何利用色彩的力量来讲述故事，将有助于你更好地与目标受众互动且建立强烈的情感联系，并在这个争夺思想、心智和金钱的竞争激烈的市场中建立更大的品牌资产。
>
> ——潘通色彩研究所副总裁
>
> *In our visual society, understanding how to leverage the power of color to tell your story will help you better engage and create strong emotional connections with your target audience, and build greater brand equity in a marketplace where competition for share of mind, heart, and pocketbook is fierce.*
>
> *—Laurie Pressman, VP, Pantone Color Institute*

Metallic colors include gold, silver, bronze, symbolizing wealth, prosperity and success

□ Associated Meanings

Gold and silver are both precious metals, associated with riches and expensive jewelry. Gold is the most materialistic of all colors, symbolic of wealth and extravagance, with some of the psychological attributes of yellow. Silver is a solid color visually characterized by a sleek, metallic shine and typically associated with the color grey. Bronze captures the qualities of brown, and so it is more earthy, natural, and mature.

□ 情感效应

　　金色是铜色、黄色和棕色的近亲，带有光照、爱、同情、勇气、激情、魔力、智慧的情感效应；银色则偏冷，跟灰色很像，但却更生动有趣，它与黄金一样同是贵金属，代表着希望、冥想、温柔、友善、敏感、心灵感应能力和无条件的爱等。

设计应用提示：
• 亮银色意味着启发新思路和直觉。
• 暗银色可能意味着负面的东西，比如恐惧。
• 亮金色足够吸引眼球，可以代表灵感和精神能量。
• 在设计中，暗金色通常比亮金色表现得更加丰富、温暖和强烈。
• 在印刷中，使用专色印刷来获得金属色调和金属光泽。
• 黑色和金色的搭配可以立显"奢华"感。

Poster design by Pinch Studio

　　烫金色酒标与黑色的整体包装，Esteban T为Petit Verdot赋予了独特的感觉。

Petit Verdot by Esteban T

　　潘通金属色用于印刷和包装，使设计发光、炫目并吸引眼球。

　　配件的魅力在于它们几乎可以在任何地方使用。在房间内散点式地使用相同的金属色装饰家具和织物，可以营造出理想的外观。

　　如果觉得金色有点过于显眼，但又想让标志脱颖而出并略带奢华，那么银色的诠释是实现这一目标的另一方式。

Logo design by colored　　　Logo design by Maria Nersi

Pantone metallic colors for print and packaging.

☐ Emotional Response

The color gold is a cousin to the color bronze, yellow and brown, and is also associated with illumination, love, compassion, courage, passion, magic, and wisdom. Silver has cool properties like grey but is more fun, lively, and playful. It is a precious metal and, like gold, represents hope, meditation, tenderness, kindness, sensitivities, psychic abilities, and unconditional love.

Tips for use in Design:
- *Bright silver opens up new ideas and intuitiveness.*
- *Dark silver can mean negative things, like fear, is accumulating in the body.*
- *Bright gold catches the eye and represents inspiration and activation of spiritual energy.*
- *Dark gold is often richer, warmer, and more intense than bright gold in the design.*
- *The effect of metallic tones will be seen on printed materials, using spot color printing to obtain metallic sheen.*
- *For a look that instantly says 'luxury' in label design, black and gold can never go wrong.*

Hot gold foil on a black background gives this wine label design and packaging by Esteban T an exclusive feel for Petit Verdot.

Pantone Metallics for printed materials help make designs shine, dazzle and attract attention.

The beauty of accessories is they can be incorporated just about anywhere. Use same colored metallic pieces placed in multiple areas within a room to accent furniture and fabrics to create the desired look.

Photography by Laminex Ferro Grafite

If you want your luxury logos to stand out, then gold is a bit obvious, isn't it? A silver logo is a subtle way to accomplish that.

如何生成色彩创意？

How to Generate Idea
—Color Creation?

关于色彩创意的思考

色彩的本质应该改变——不是表象的变化，而是感知层面的真正改变。

——雷姆·库哈斯

　　色彩在视觉信息中通常是最易和最先被识别的部分。作为设计中的重要元素，对色彩的疏忽当然有可能导致设计方案的功亏一篑，色彩的设计不仅关系到色彩的表现效果，也涉及方案整体的成功与否。然而，"色彩问题"的提出并不常在设计思考的初始阶段，而是多在设计进程的后期才被讨论。那么色彩既然作为设计的"功能组件"，就很有必要尽早地与创意策略结合，这样可以在设计初期就发现一些潜在问题，并在迭代创新的进程中实现色彩表现与其他设计元素间的相得益彰，这当然是越早越好。

　　色彩理论家对色彩的通感特征进行了关联性的描述：轻、重、强、弱、软、硬、脏、干净以及许多其他特征。这些对特征的描述虽体现了一定的普遍性，但又往往因为含糊而无法在设计过程中形成明确、有意义的评价。当一种原理或方法变得收效甚微甚至束手束脚时，那就有必要突破和尝试新方式了，设计师们善于灵活运用色彩原理，追求原创、不断思考并努力探索新领域。

　　色彩创意正是要享受设计创新的过程，减轻已有规则带来的束缚，当然也要做好失败的准备。好奇心与正能量可以帮助我们做好离开舒适区的准备，让我们在试错中尝试新方法、发挥创造力。因此，在培养色彩创新思维能力的过程中，不用过度关注他人的想法，需要的是更大限度地解放自己的想象力。总而言之，色彩创意是一个不断发现的旅程，色彩带来的创意灵感无处不在。

创意生成的4个小技巧：
1）远离网络——如果你一开始就上网搜索提示方案，思想就会受到网上信息的限制。
2）换个角度/环境——如果你发现很难有一个好想法，那就更换个角度或方向思考，或者换个新环境通常也会有帮助。
3）多点触发——参观博物馆、美术馆或去参观一下学校里的其他专业，学会突破自我的专业边界去看待问题。
4）保持简单——任何没有充分理由的复杂化都会成为新问题，或是需要花费更多的时间和金钱。

4-Tips for Generating Idea:
1) Stay away from the Internet. If you go online from the beginning, your mind will bear the burden of vision.
2) If you find it difficult to come up with a good idea, then switch to another direction. Often change places you think are helpful.
3) Different trigger points. Visit museums, galleries, other departments in the University. Think beyond your own boundary.
4) Keep it simple. Anything complicated without good reasons will become a problem or have a high cost.

Inspiration for Color Selections

The nature of color should change—no longer just a thin layer of change, but something that genuinely alters perception.

—Rem Koolhaas

Color is generally recognized sooner than any other element attached to an object, including overall form. It is an important component in the design process, and if it is not considered carefully, it can also become the deciding factor between a product being successful or not, no matter how well-considered something is in all other areas. It is often the case that colors are not considered in the initial stages of an idea emerging and frequently only make an appearance in the latter stages of the design journey. There is a difficult balance to be struck in the use of color, but generally, the sooner it is associated with an idea, the better. The reason for color to often make a late appearance in the design process is perhaps understandable in the sense that a design or an idea could be rejected inappropriately in the initial stages simply because of a particular color association, but the color should be considered to be a functional component.

Color theorists have often demonstrated that color can be associated with a range of characteristics due to previous tangential experiences, but such theories tend to be generic and are often too vague for meaningful appraisal in the design process. Colors of all descriptions can be considered heavy, light, strong, weak, soft, hard, clean, dirty, in addition to many other characteristics. Designers constantly think about original directions and explore the unexpected. This is inherent to being creative. Sometimes it is necessary to do things differently because an approach has simply become hackneyed, banal or sterile. Color creation is about enjoying the design process. It is about moving forward without restraint and being prepared to make mistakes in addition to discovering innovative pathways. If we can get rid of reluctance and feel ready to leave the familiar comfort zone, there are many opportunities to be creative. In developing a color experimental play mindset, it is necessary to improvise and engage a flexible imagination. It is not important what others think as it is a journey of discovery. Inspiration for color selections and combinations is everywhere.

9个实验游戏——唤起你的色彩创造力

❝

'世界初始,一片荒芜,黯然无色。
一天又一天,上帝浇灌、种植,创造出了五彩缤纷的世界。'

　　这个抒情的故事把每一天的创作都赋予了一种色彩。第一天,上帝将果断、有力的黑色与萧瑟、苍茫的白色区分开来;第二天,上帝将蓝色的泡泡洒满了天空,倾注到海洋;第三天,草木葱茏,令人神往……这个故事一直持续到第六天,庆祝着人和动物的多样,直到第七天上帝休息时结束。

　　　　　　　　　　　　　　　　　　　　　　　　——安·科夫斯基

❞

　　"除非你亲身经历,否则你没有切身体验。"IDEO公司的联合创始人(1991)比尔·莫格里奇对切身体验的表述虽然不是特指包豪斯精神,但它却呼应了约翰内斯·伊顿的互动理念,以及康定斯基和保罗·克利所提倡的实验和直觉的方法。

　　先入为主的看法和观点、实验和玩乐的缺失,都会阻挠创造力生长的进程。色彩的实验游戏是色彩创意的基础阶段,以类似于玩耍的方式进行对话与互动,亲身体验和尝试对创作对象的重新塑造。如果我们需要挑战传统思维或既定的规则,就应该持有"问题意识",考虑新途径、新方法。因此,在这个阶段我们采用了更为开放的游戏化方式,简化问题并在试错中激发潜在的创造力。

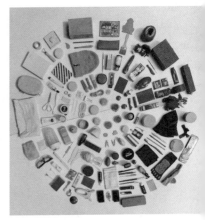

IMG: Design by Ye Li and Li Conghui

❝

野心和游戏是设计的两个基本组成部分。

❞

 实验游戏1——碗和杯子

　　实验游戏1是对绘图工具概念上的转换,北京街头商贩兜售的陶瓷碗、塑料杯碟、金属器皿等为后续系列的绘图工具开发和色彩实验游戏提供了灵感。在对绘图工具的初始尝试与再设计的实验游戏1中,一次性碗盘更加容易与画笔组合,也带来了更好的使用体验。这

9 Inspiring Experimental Plays to Awaken Your Color Creativity

'In the beginning, there was nothing. No colors at all.
Day by day by day, God poured and planted and created the colors of the world.'

This lyrical story pairs each day of Creation with a color. On the first day, God separated the crisp, strong blacks from the wintry, pale whites. On day two, God poured bubbling blues across the skies and into the watery oceans and seas; On day three, lush greenery gladdens the heart...The story continues until the sixth day, which celebrates the diversity of animals and people, and ends with the seventh day when God rested.

—Ann D. Koffsky

Bill Moggridge, co-founder of IDEO (1991) stated, 'you can't experience the experience until you experience it'. Although the statement is not directed particularly at the ethos of the Bauhaus it does in many ways echo the sentiments of Johannes Itten's importance of interaction and also the experimental and intuitive approaches promoted by Wassily Kandinsky and Paul Klee.

Preconceived views and opinions, a lack of experimentation and play can stifle the creative journey. The manipulation of actual objects and the coupling of unfamiliar items to consider alternative dialogues is analogous to play. Experimental Play is a color creation process that is fundamental to being creative. It is necessary to challenge conventional thinking, question why things are done the way they are, and consider alternative directions and ideas. There is nothing wrong with adopting a fundamental play process, to simplify thinking and embrace a tinkering process to trigger the creative process.

Ambition and play are two of the essential components of design.

 1 Experimental Play—Bowls & Cups

Vendors in Beijing selling a variety of ceramic, plastic and metal bowls and plates on the street. The objects provided inspiration and influenced a series of creative directions to develop the experimental play. The concept of #1experimental play was based on

些简单组合而成的绘图工具以无规律或偶发的持续移动方式来勾画线条,这些线条组成的图形是否太过幼稚? 还是带着有着天真的童趣意味? 暂且不去评判美感,也不要过于担心经验性的非对即错的结果,而是聚焦在我们是否以不同的方式来进行挑战与尝试。此类非批判性的实验游戏有其明确的目标和指向——试错中对常规的挑战并找寻可持续的创新方式。从根本上说,试错过程即是一种实验,关注的是过程的价值,而非结果。

英国林肯大学的学生们除了使用上述方法也尝试在杯盘的底部直接涂上颜料印制,这也是儿童时期经常玩的小游戏。后期可以提取这些印记图形进行重新组合与构成,并通过丝网印刷技术改变原有的色彩和组合方式。丝网印刷为这些印记的复制、色彩的再设计以及构图的改变提供了便捷的途径。

简单来说,丝网印刷是通过制作带有图文的丝网印版(制版),再施以油墨予以上色。在每一幅手工丝网印刷作品中,虽然构图相同,但都是可以主观地创造色彩与细节上的变化,这正是丝网印刷的价值,保留了手作的温度并降低了复制过程中的风险,它比手工绘画更能提高手工制作的确定性和可复制性。

材料清单:
4张丝网板　　　　　　　　　　　登记标签
4张乙烯基塑料剪影(需要的颜色各1张)　纸或布料
1个清洁刷　　　　　　　　　　　美纹纸胶带
1个油墨刮刀　　　　　　　　　　木制或纸板垫片
4种油墨颜色

utilizing different types of bowls, cups and plates during a design process, but the use of paper bowls provided an insightful opportunity to further explore mark-making by actually attaching different mediums. These simple drawing machines were continually moved around various forms, the chaotic movements of the user and the unreliable consistency of the object.They created a variety of unexpected marks on the surface. Are these marks beautiful or are these marks too childlike? Perhaps they are both? The importance was centered on the type of mark that could be created, the experimental and non-judgemental play that was conducted without being too concerned about any particular outcome. The approach has an inherent outcome which is to challenge convention: what is or isn't acceptable. Fundamentally there is no right or wrong. The process is an experiment. It is a valuable process, whatever the outcome is.

In addition to the marks created in Lincoln using metal containers, plastic basins and a variety of other alternative medium holding objects, plastic cups were inked on the underside, and a series of simple prints formed. Combining these prints with an array of other print marks that had been created by various means provided an opportunity to explore mark-making and color through screen print. The screen printing process provided an opportunity to repeat marks and to select different compositions and colors.

Screen Printing involves creating a stencil, known as a screen, and then using it to apply ink on the printing surface. We can usually find differences in manual screen printing in every single work. This inspired us to imagine manual screen printing, which can raise handmade certainty more than hand-painting can do and reduce the risk of handmade.

Materials List:
4 Screens
4 Vinyl cut outs (1 of each color you want to print)
A squeegee
An ink spatula
4 colors of ink

Registration tabs
Papers or fabric
Painter's tape
A wooden or cardboard spacer

实验游戏2——水桶和盆

实验游戏2进一步改进了实验游戏1中色彩印记的制作方法,通过互动的游戏方式导入色彩理论的学习,要求创作者依据伊顿的色彩理论来探索更多的色彩关系与色彩搭配方案。

实验过程中没有明确的规则和约束,而是鼓励实验者去体验容器及工具的改变所带来的差异,同时对绘制工具进行迭代创新。通过在容器的非中心位置开孔,并在底部安装简易的滑轮,让油漆、墨水或漂白剂等液体流下并附着到画纸、布料等介质上。改造后的容器通常围绕某一物体的外部形态自转,或是在限定的区域内旋转及自转,例如呼啦圈内;旋转容器时,其底部的滑轮带动了颜料的混合,可以创作出表面看似繁杂但实则有序的形式。随着色彩的逐层附着、随机的图形相互叠加,多变的效果和色彩间的调和随之产生。

制作步骤提示:
步骤1:观察不同容器的特征,如塑料盆、桶等,最好选择那种有垂直的壁沿并且底部平整的容器。
步骤2:在容器底部安装滑块或轮子,并在底部开一个直径约3mm的小孔。
步骤3:在容器的开孔处(外部)粘上一小片纸胶带。
步骤4:水粉或丙烯颜料中加入少许水搅拌均匀(后面可以根据需要再次加水),放入空塑料瓶中,盖紧防止变干。
步骤5:将塑料瓶里调和好的颜料倒进准备好的容器中。
步骤6:在平坦区域铺一张大纸并用纸胶带固定其边缘。
步骤7:找一个可以让容器围着旋转的物体放在纸上。取下密封小孔用的胶带,沿着中心物体的边缘一边旋转一边移动,颜料会从容器中流到纸面形成图案。
步骤8:保持纸面平整,等颜料变干后可以考虑再次添加其他色彩,重复步骤7。

 ## 2 Experimental Play—Basins & Buckets

#2 Experimental color works provide an opportunity to explore further mark-making and potential for introducing color theory through actual interaction using the experimental play approach. The creation of the color experiment will embrace the Itten color theory and will also present the opportunity to challenge color combinations and relationships in color.

The combining of colors through the use of different containers and formers creates a work on paper that is considered but without obvious constraint. The attaching of simple wheels to the underside of the containers and the making of an off-center hole allowed for liquids such as paint, inks or bleach to flow onto any surface below. The marks are randomly blended as the sliders on the underside of the containers blend the medium. The rotation of the containers around forms, or within forms such as large hoops provided the opportunity to create a variety of seemingly chaotic but ordered prints. The unexpected marks and bleeds between the layers generate an opportunity for infinite outcomes.

Step-by-step Tips:
Step 1: Identify different plastic containers such as a plastic basin, bucket or similar. Ideally, the container will have almost vertical sides and must have a flat base.
Step 2: Add sliders / wheels to the underside of the container and carefully make a small hole approximately 3mm in diameter.
Step 3: Put a small piece of tape over the hole of the container, which has the sliders/wheels attached. The tape must be on the outside of the container.
Step 4: Mix up water-based paint in a separate basin or bowl but do not add too much water. More water can be added later as required. Place the mixed paint inside an empty water plastic bottle and replace the lid.
Step 5: Empty the pre-mixed paint stored in a plastic bottle into the basin or bucket being used.
Step 6: Find a lat area to work with plenty of room. Place a large sheet of paper onto the surface and secure it at the edges with paper-based tape.
Step 7: Find an object that the bucket/basin of paint can be rotated around and place on the paper. Remove the tape that was sealing the hole and working quickly rotate the bucket / basin around the object. Paint or ink will drain from the container onto the paper creating a pattern.
Step 8: Allow the paper to dry but keep it flat. Consider adding additional color.

■ 实验游戏3——瓶子和滑板

颜料作为媒介用于大型艺术品的创作,可以产生所见即所得的视觉效果,这为创作系列作品和体验多种色彩关系创造了便利条件。实验游戏3对先前的创作进行了改进,原先盆桶类的绘图工具被木制模板替代,部分模板被切割成类似滑板的形态,两端带有弧形边缘,这样有助于转动和颜料的输出。新工具创作的图形类似于大笔刷在有规律地运动,作品的效果比实验2中的创作更加丰富和可控,这也促使我们进一步思考不同方式、途径和目标、结果之间的关系。

作品"雏菊"是在布料上创作的,黄色和绿色的叠加带来了微妙的色调变化,对作品创作过程的控制突出了图形的整体感。滑动而产生的线条形成了秩序性的缠绕,颜料的持续叠加进一步创造出了更为复杂和精密的图形;实验同时也为团队成员间的互动与协作提供了机会——共同考虑和控制色彩调和带来的相互影响。

制作步骤提示:
步骤1:找一个可以存放颜料的瓶子(如牛奶瓶、矿泉水瓶、果汁瓶)。
步骤2:将轮子或滑块安装到裁切好的木板上,使其在纸面等绘制界面上可以自由移动。
步骤3:将瓶盖固定在木板的另一面。
步骤4:在瓶盖周围涂上防水的密封胶(如热熔胶)。

3 Experimental Play—Bottles & Skateboard

The instant outcomes that were achievable through the creation of large artworks using a liquid medium provided an opportunity for multiple works to be created and multiple color combinations to be considered and experimented with. Developing the practice of using paint in buckets or basins can be achieved by the use of wooden forms. Simple, elongated forms, usually with a rounded edge, can deliver paint or ink. The works appear to have a characteristic that is similar to the movement of a large brush across the surface rather than having been created with abandoned metal and plastic containers and prompts consideration to what other objects and outcomes could be achieved.

Print like Daisy was created on fabric with a subtle combination of the colors yellow and green that introduced a variety of associated tones. The control of the work emphasized the overall formation image. The marks of the sliders can be seen throughout the work and create a tangled pattern with the main body of the image. Continuing the built-up of medium would create an intricately patterned circle and presents an opportunity, through group interaction, to consider the impact of surrounding colors on other colors.

Step-by-step Tips:
Step 1: Find a waterproof container—for example, a milk bottle, a water bottle, a juice bottle.
Step 2: Attaching wheels or sliders to the underside of the wooden former will allow it to move freely over the surface that is to receive the ink.
Step 3: Attaching the bottle cap to the surface of the wood.
Step 4: Have a sealant around it, such as waterproof glue.
Step 5: A small hole can be made that goes through the bottle cap and the wooden board. The hole should be about 2mm to 3mm in diameter.
Step 6: Paint previously mixed and placed in a bottle can be attached to the fixed bottle cap, and tape should be used to seal the hole to prevent paint from leaking temporarily.
Step 7: A small hole should be made in the bottle's bottom— the opposite end to where the cap is. This allows air into when ink or paint is flowing out. Without this hole, the color will not flow smoothly.
Step 8: The rotation of the skateboard around forms or within forms such as large hoops.

步骤5:在瓶盖内打孔并穿透木板,这个小孔的直径约在2mm到3mm之间。
步骤6:将装好颜料的瓶子旋紧到安装好的瓶盖中,用胶带暂时封住小孔,防止颜料渗漏。
步骤7:在颜料瓶子的底部打孔(瓶盖的反方向),使空气进瓶中,以保证颜料可以顺畅地流出。
步骤8:围绕中心物体(或是在大型的圆环内部)旋转及自转。

实验游戏4——随物赋形

实验游戏3中的圆形空间是否可以改变? 一定要是圆形吗? 这也是个有趣的探索方向。作为一个团队,共同创作的方法有很多,可以先试一下这种方式:沿着相对笔直的物体旋转颜料容器来创造水纹状线条。

制作步骤提示:
水纹A
步骤1:使用像实验游戏2或3里的容器,添加颜料。
步骤2:找一个大约1m长的物体:竹子、伞、长木棒、拐杖……
步骤3:沿着物体旋转装有颜料的容器,创建一条大约5m的长线。
水纹B
步骤1:尝试用棍子横跨纸张,而不像A中沿着纸的边缘绘制波浪状水纹。
步骤2:依据纸张长度,反复依次绘制并逐步调整色调(如选择蓝色调后,绘制大约5行后添加少量深蓝色,继续绘制数行;然后再次添加等量的深蓝色绘制数行,依此类推)。在这里,线条不再是"水纹A"中的表现主题,而是作为构成元素辅助表现渐变色这一主题。

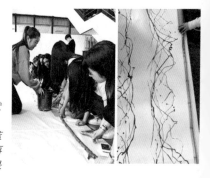

那么,除了圆形、线形以外的其他形态呢? 当然要继续尝试新方法,图片中展现了依据人体形态创作的过程。实验、好奇、乐趣、合作与交流是这个色彩实验游戏的关键词。绝大部分作品的创作是以随机的、意想不到的或难以预测的方式进行,所产生的结果也不都是尽如人意,试错导致的失败都有其价值。对于形式和方法的探索从未停止,不去思考"如果"就很难把想法向前推进,也不可能产生原创的思想。

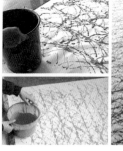

 4 Experimental Play—Sticks & Inner Shapes

Whether the distinct circular space in the center of the workpiece of #3 Experimental Play can be changed is also one of the interesting directions to be explored in our experiments. Does it have to be a circle? Experiment with other approaches that we as a group can create. You can try the following way first: the creation of a water artwork was achieved through rotating containers of paint along a long line of relatively straight objects.

Step-by-step tips:
Water A
Step 1: Use a found container and add paint, such as #2 or #3.
Step 2: Found objects of approximately 1 meter in length. (Such as bamboo, umbrella, piece of wood, walking stick)
Step 3: Rotate the container against a straight object that is 1+ meters in length to create a 5 meters line eventually.
Water B
Step 1: Create a water image as before, but sticks are to go across the paper rather than along it.
Step 2: Gradually work down the paper adjusting the tone with blue color and do approx. 5 lines, then add a small, but measured amount of shade of blue and create a further 5 lines, then add another equal measure of Blue and continue to repeat. Utilize the same practice as long water but was constructed as a body of lines rather than a continual line.

实验游戏5——切割刀与艺术灵感

理解工具、观察对象、以简单的方式再设计,这些都是培养创新意识的方法,也是提高教学质量的有效手段。为了进一步改进色彩游戏实验方法,该组实验从使用颜料造型转向了使用机器雕版,以切割的方式制作图形。主要的制作方法是将手持切割机连接到两端不对称的木质模板上,对木材表面进行切割,模板的长度和形状会直接影响到切割刀移动的轨迹。

制作步骤提示:
步骤1:寻找或制作符合形状要求的木质模板。
步骤2:将切割机固定在木质模板上。
步骤3:调节切割机刀头的长度,尝试不同的切割深度所带来的效果。
步骤4:紧贴着圆环内壁旋转带有切割刀的模板,务必使模板的每处边角都接触到圆环内壁。
步骤5:切割完成后,用金属刷去除影响后续印刷效果的灰尘颗粒或小木屑。

Does it have to be a circle or a line? The pictures demonstrate the process of generating marks around the human form and continue the experimental play approach. Experimentation, curiosity, fun and a desire to talk to the community have been the main focus of this experimental color play. Most works that are created from the random and unexpected or unpredictable delivery of medium onto a surface creates an outcome that is impossible to replicate. The process creates a unique outcome. A range of various forms and techniques was explored. Failure was as important to the evolving process as a success, without questioning what if it is difficult to move ideas forward and explore original thought.

 ## 5 Experimental Play—Cutter & Artistic inspiration

Understanding tools and observing how simple objects can be transformed into viable outcomes is so valuable in creating proposals that support the design practice and improve the quality of teaching. To develop the approaches of experimental play with the medium, which replicated using paint to the creation of formers but utilized machinery. The attachment of a cutter to an asymmetrical plate provided an opportunity to explore cuts into a surface either as a primary mark-making method. The length of the plate that the cutter is attached to relates directly to the form that the cutter is being moved around.

Step-by-step Tips:
Step 1: Find or create various pieces of wood.
Step 2: The cutter is attached to a piece of wood prior to the creation of cut marks.
Step 3: Adjust the cutting head to control the cutting depth.
Step 4: Press and rotate wood along the inside of a hoop, make each corner and edge of the wood closely contact the hoop's inner wall.
Step 5: Once cut, the wood was brushed with a metal brush to remove any dust particles or a small piece of wood still attached that might impact the print to be made.

Bramston & Mi Young Jang, Lincoln UK

这个教学实践项目从中国和英国的经典艺术作品中汲取灵感,进一步深化机器雕版中色彩与形态的提取方法,创造新的形式并实现关联的印记。该方法也为后续印前图像的创作提供了潜在的创意基础。

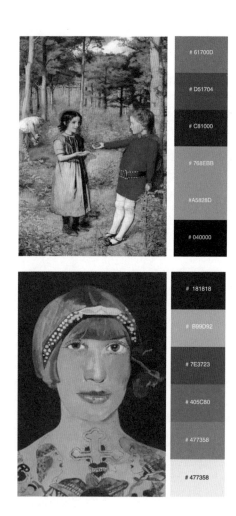

色彩创意 像设计师一样思考色彩

This practice teaching also involved utilising found leading artworks to make marks. The marks making used found paintings from Chinese or British collections inspire the print formers and the colors utilized. Experimenting with practices and approaches to making woodblock marks provided an opportunity to explore the potential of generating preprinting imagery.

■ 案例解析

— 赏析英国艺术品《拿气球的女孩》: 这是班克斯最重要的作品之一。这幅作品描绘的是一个女孩, 她的头发和衣服在风中飘动, 正伸手去抓一个从手中滑落的红色心形气球。

— 确定绘画中不同色彩的百分比: 班克斯的这幅作品颜色的百分比大致是灰色80%、黑色15%、红5%。

— 利用心形气球的形状制作模板: 在废木板上绘制气球图像草图, 然后切割。

— 将气球形状的模板连接到切割刀: 打孔以便切割工具可以穿过模板。

— 将切割刀放在大木板上: 切割刀头穿过孔洞, 接触到模板下方的大木板, 刀头切入木板的切口深度约1.5mm。

— 紧靠夹尺边缘旋转带有切割刀的气球模板: 沿着直线边缘前后移动大约6次。每次切割后, 略微移动切割刀, 以使线的起点略有变化。稍微移动切割刀将确保6次分别切割不同的线。

— 继续沿夹尺边缘旋转切割刀: 沿夹尺边缘旋转切割刀约6次后, 将尺移动约40mm, 并开始切割另外6行。切割后继续移动直尺, 反复以上动作在木板上形成图案。

— 80%灰、15%黑、5%红: 使用制成的雕版印制具有原作色彩特征的创意图形, 该图形还会被进一步用作布料上的印花纹样。

▉ Case Study

- Review artworks in British art collections: Girl with a Balloon, or Balloon Girl painting, one of Banksy's most important works. The work depicts a young girl whose hair and dress are blowing in the wind, reaching for, or releasing, a red, heart-shaped balloon that has slipped from her grasp.

- Identify the percentage of different colors in the painting: the painting of Balloon Girl has a basic percentage color of 80% Grey, 15% Black and 5% Red.

- Utilise the heart shape to create a wooden former for print: Balloon image sketched out onto scrap wood and then cut out.

- Wooden balloon shape attached to the cutting tool: create a hole so that the cutting tool can go through the balloon shape.

- Put the cutter on the board: The cutting tool can touch the board underneath the balloon due to the hole. The cut makes into the board is about 1.5mm only.

- Rotate the cutter attached to the balloon shape along a clamped edge: Go backward and forwards along the straight edge about six times. After each cut, move the cutter slightly so that the starting point for the line changes. Moving the cutter a little will make sure a different line is cut each of the six times.

- Keep rotating the cutter along the straight edge. After rotating the cutter along the straight edge about six times, move the straight edge about 40mm and start to cut another six lines. Move across the wood developing a pattern.

- 80% Grey, 15% Black and 5% Red: Developing the print process's practice is to progress to printing on fabric and the construction of a series of creative graphics that have the essential characteristics of the original color scheme.

实验游戏6——雕版印制（色彩、纹理和形式）

雕版印制的原型模板由戴维和叶莉在2015年制作，色彩是通过使用不同尺寸的滚轴并借助滚动过程中不同的压力将木板上的纹样转移到纸面。在过程中依据色彩理论进行油墨的混合，多次印制可以实现不同的色彩感知与强度变化。

《斑马》(2016)的创作就是使用了单色变化。斑马系列只使用了一个雕版印制而成，板子旋转一定的角度进行印制，多次重复形成了图层不断的叠加。图层增多，图像变暗，明度产生变化的同时，图像也越来越复杂。

Zebra (2016)

TBC (2016)

Purple (2015), Layered design created by South Korean designer Mi Young Jang, Ye Li and Dave Bramston

6 Experimental Play—Wood block Prints

The original formers for this design were created in 2015 by Dave Bramston and Ye Li in Lincoln, UK. These were created by using a different roller with a density that allowed an imprint of the wooden former to be made on the roller if it was rolled hard enough over the wooden surface during printing. By doing this, the imprint created on the roller transferred onto the pattern and created the image. As with color theory practice, the adjustment of an outer color would be expected to influence the perception and strength of the inner color.

The Zebra (2016) prints demonstrate tonal differences in a single color. The Zebra series of prints were created with a single former. The rotating of the former created the impression of an ever-increasing complicated pattern that also got darker and darker as more layers were created.

Print created by designer/educator
Yuling Xu, Tangshan 2016

案例解析

— MAIDE团队使用色彩实验游戏5中的方法制作雕版。

— 已完成的部分圆环和圆形雕版，可以单独使用，也可以二次上色时叠加使用。

— 可以进行印记的叠加雕刻。

— 着色方式A：印刷之前用手持式滚筒为雕版上色（水性油墨）。再将纸张放在着墨的雕版上，用干净的滚筒用力滚动按压，使颜色从模板转移到纸张上，掀开纸张即可看到印制内容。清洗雕版后，可二次上色进行新的创作和印制。

— 着色方式B：油墨上色于滚轴之上（模板不着色）。该方法中滚轴的尺寸变化会直接影响油墨附着面积和图像的表现形式，另外油墨的使用量以及滚动方向的变化同样会影响色彩的表现效果。

Black (2016)

— A与B结合：结合这两种方法，例如在创作"蒲公英"图案时，先用较浅的色彩作为背景色，然后用带有较高饱和度色彩的小滚筒塑造一些细节。

Deep water (2016)

Dandelion (2016)

■ Case Study

- MAIDE team explores the creation of marks into a board using the same #5 Experimental Play processes.

- Completed circular formers. The potential to print from a single former and then replace it to create a secondary print that would overlay the first image was possible.

- Overlaying of cut marks to create opportunities to blend colors.

- Method A: Wooden blocks with color applied before printing. Colors applied with printers, handheld roller. Papers lowered over the inked formers are firmly rolled to create an impression. A second, clean roller to firmly press the paper against the block allows for color to be transferred from block to paper. Removing the paper reveals the print. Washing the block provided an opportunity for a second ink to be applied to the original print.

Yellow & Black (2016)

- Method B: Colors applied with a handheld roller to create a multi-layered print former print. If the roller used is a large one which allows for large bands of ink to be applied. Applying the ink in multiple directions with different amounts of ink on the roller creates distinctive bands of color.

- Method A & B: Combining these two practices and was conducted in the creation of Dandelion prints. A light background of color was rolled onto paper covering the wooden formers before a small roller picked up specific details with higher saturation of color.

实验游戏7——瓶盖

据英国《卫报》报道,全球每分钟就会销售约100万个塑料瓶,该实验游戏在利用废弃瓶盖所固有的色彩进行创作的同时强调环保意识。塑料瓶的瓶盖通常也是一种薄型塑料,具有良好的透光性,这为利用光线混合色彩提供了基本条件。

在包豪斯学院,伊顿专注于色彩的对比关系(包括互补、明暗、温度、重量、饱和度等);在我们的实验中,每个塑料瓶盖都被看作一个独立的色相,不仅探讨色彩和光线间的互动,而且通过瓶盖间的套叠、并置等方式进行色彩多种对比关系的尝试。这个实验游戏可以加强对色彩理论的理解,而且还试图以非常规的方式突破思维边界,在发挥创造力的同时也培养了同学们的可持续发展理念。

制作步骤提示:
步骤1:回收一批废弃的塑料瓶盖。
步骤2:在每个塑料瓶盖上穿孔。
步骤3:用较大的瓶盖覆盖较小的瓶盖,从而创造出微妙的色调和渐变的色彩。
步骤4:将有孔的瓶盖依次套入一条线形的LED光源上。
步骤5:重复步骤4,缠绕或编排多条光源(光源间的相互映射会产生更多色彩变化)。
步骤6:连接电池或电源。

7 Experimental Play—Bottle Tops

Guardian reports that a million plastic bottles are purchased every minute. #6 experimental play utilized waste plastic bottle tops rather than a traditional medium for the experimental practice into color. The reasoning for this approach was to be environmentally aware and exploit the broad range of colors these waste materials offer. The waste plastic bottle top is also a cheap, thin plastic and therefore has beneficial translucent color properties that enable the passage of light and the blending of various colors.

At the Bauhaus, Itten focused on color contrasts, including color opposites such as purple and yellow, contrasts in light and dark, and the contrasts related to temperatures, weights and saturation. The plastic bottle top practice, acting as a single point of hue that could be mixed, blended and merged with opposite and complementary colors, enabled considerable experimentation to be conducted. The practice aimed to be proactive and present opportunities for direct interaction with color and light. This experimental play wanted to communicate not only an understanding of color theory but also attempted to push the boundaries of creativity in a free-flowing manner and be environmentally aware.

Step-by-step Tips:
Step 1: Salvage an array of waste plastic the bottle tops.
Step 2: Generate a hole in each of bottle tops.
Step 3: Small colored tops to be shrouded by more oversized tops to create subtle tones and graduated colorways.
Step 4: Tops are sourced to be threaded onto a line of the LED light.
Step 5: Create multiple, threaded light lines, which provide an opportunity for colors to bounce off each other.
Step 6: Connect to batteries or mains.

■ 实验游戏8——天然染料

　　不断尝试一直是创新的重要方法,对传统植物染色的尝试是色彩灵感的另一打开方式。天然染料可以是常见的水果也可以是中医药材,虽然许多中药表面衣不兼彩,但并不妨碍朴素无华的它们创造出美丽的色彩:苏木、五倍子、鸡血藤、栀子花……这些都是低调而美丽的天然染料。

天然染料染色步骤提示:
步骤1:在染制大幅布料之前,要先从染色小样开始了解将要使用的天然染料的特性和处理方法。
• 方法A:碾碎植物原料,通过使用研钵和杵类工具反复捣压、碾碎材料释放色彩。
• 方法B:通过水中加热的方式释放并提取色彩。

步骤2:记录日志(使用的方法和步骤)。包括染料的数量、制备方法、水量和温度的变化,其中记录染料的名称和来源十分重要。
步骤3:通过折痕、褶皱等表面痕迹处理,展现独特的图案。
步骤4:用水稀释或混合提取出的色彩以创造各种色值、色调和色相变化。
步骤5:过滤掉杂质,防止附着在布料上。
步骤6:摊开晾干布料。
步骤7:借助设计思维和头脑风暴的流程框架,生成与天然染料有关的创意想法。

8 Experimental Play—Natural Dyes

Experimenting is always a meaningful way to discover something original, and natural plant materials provide a catalog of interesting color opportunities and combinations. Natural dyes can be created using a wide and varied array of materials. Many Chinese medicines can create beautiful colors even though they might not offer any suggestion of the color they contain within. Often dull and unassuming, they can reveal beautiful colors and present diverse opportunities. Su Mu (Sappanwood), Wu Bei Zi (Gallnut or Chinese gall), Ji Xue Teng (Caulis spatholobi), Zhi Zi Hua (Gardenia / Jasmine) are just a few examples of the medicines that have a hidden beauty.

Step-by-step Tips for Using The Extraction of Color from Plant Material:
Step 1: Start with fabric samples or swatches to understand how a natural material will respond to various treatments before committing to larger bodies of work.
• Method A: Crushing small pieces of the plant material. The repetitive pounding or crushing of materials using a mortar and pestle or a similar force applies tool release dye.
• Method B: Plant materials that are heated in water to extract color.
Step 2: Record the methods used and the steps, including the number of natural materials, preparation techniques, liquids used and temperature/ temperature changes, among which the source of natural materials is the most important.

Step 3: Reveal unique patternation through creases, fold and other surface marks.
Step 4: Diluted with water to create a variety of tonal strengths or the mixing of natural material enables colors to be developed.
Step 5: Filtered out the unwanted matter to prevent attachment to fabric.
Step 6: Layout the fabric to dry.
Step 7: Follow a generic framework for creative thinking and brainstorming, and discovery associated with natural dyes can.

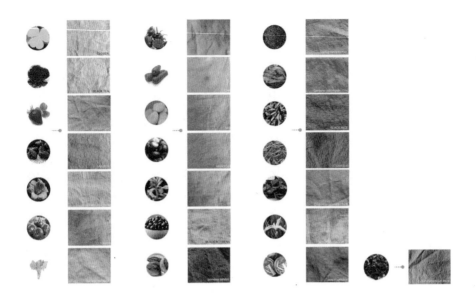

⬛ 染色小样

染色小样和初始试样不仅是样本和参考,用以了解和衡量显色效果,同时也是探索天然染料染色的必要阶段,需要对其进行归类和整理。染色小样的收集易于观察不同自然材料显色之间的相似和差异,也可以发现不同布料染色效果间的参差。

⬛ 制作色彩调色板

水中染色时,通常需要均匀地将布料上色,如果水和染料的比例发生变化,那么色值自然会产生变化。创建渐变的色调就可以通过稀释染料来实现,准备多个容器装有不同比例的水和染料,分别浸染上色。这种做法类似于画家调色,通过水对颜料的稀释来实现色彩上的变化。

⬛ 折叠与捆扎

在这个阶段,设计问题暂时被重新定义,从色彩的提取方式转换到对纹理的表现设计上,关注纹理结构的形式变化对色

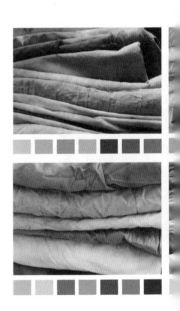

■ Color Samples

The color samples are for reference, for understanding and gauging appropriateness. Samples and initial test pieces are a necessary stage in exploring color with natural dye. The investigation and inquiry need to be documented throughout the process. The gathering of color swatches also enables similarities to be readily observed between colors created by different natural materials. The fabric samples allow for many questions to be answered and additionally present an opportunity to determine which fabric will most suit a particular dye.

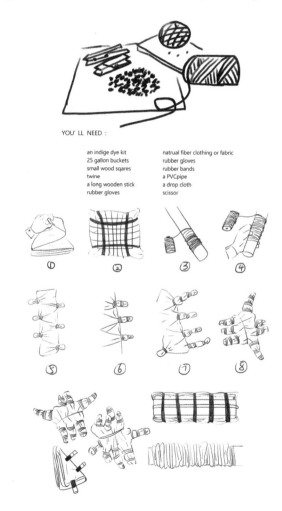

YOU' LL NEED :

an indige dye kit	natrual fiber clothing or fabric
25 gallon buckets	rubber gloves
small wood sqares	rubber bands
twine	a PVCpipe
a long wooden stick	a drop cloth
rubber gloves	scissor

彩功能的影响。混合使用多种工具和设备以产生纹理效果,例如夹子、捆扎、打结或任何方式,在创新思考的同时也为进一步研究色调变化提供了机会。

— 折叠:通过折叠布料对上色产生影响,对布料的褶皱可以参考传统的折纸、裁缝或者服装设计师制作的褶皱和折叠的形式。对类似形式的参考不仅是种方法的借鉴,更是灵感激发的方式。

— 扎捆:将布料放在两块木头或平整的物体间加紧,然后用细绳或橡皮筋将其绑在一起,物体和橡皮筋将防止染料渗入覆盖的织物中;还可以用绳子或带子有规律地捆扎布料,当它们被解开时通常会显示出规律的图案。

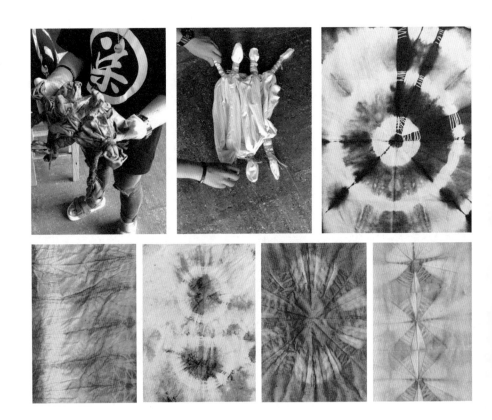

Color Palette

When a fabric is being dyed in water, it is often a requirement to achieve a uniform color throughout the fabric. Different ratios of water and natural dye-producing material can also be explored to understand the strength of color that can be achieved. The generation of graduated tones can be created through the use of multiple containers, each containing different amounts of water and equal amounts of natural dye. The practice is simply analogous to the artist's palette where the paint is diluted with water to achieve differences in the color strength.

Fold & Bind

In this process, the design problem is temporarily redefined from a study of color to what to use to create texture and how it can be attached to generate maximum impact. Mixing multiple tools and devices to create a crease, such as clamps, ties, knots or any other combinations, continually drives thinking forward and presents an opportunity to further study tones.

- The preparation of material to be dyed and the folds that might be created to exclude exposure to dye might be in reference to traditional paper folding techniques such as origami or perhaps the darts, pleats, folds that a tailor or fashion designer creates. Such analogous references can be found and can usually suggest and inspire the imagination.

- Place fabric between two pieces of wood or any flat-shaped object, and bind it together with string or rubber bands. The shapes and rubber bands will prevent the dye from penetrating the fabric they cover. Mathematical forms wrapped up tightly and bound with strings or ropes will generally reveal the initial form when they are unwrapped.

小技巧:
　　盐可以作为天然染料的固色剂,会对染色效果产生影响。因此,使用盐水或海水浸泡可以保持染色的牢固。

Tips:
　　Salt can be used as a component agent to fix the natural dye and therefore the use of salted water or seawater can also have an influence on the dying process that can be different from natural water, which is more commonly used.

实验游戏9——照明解决方案

通过实验和游戏来理解材料的特性可以洞察其潜在的创新价值,廉价的半透明塑料制品(如碗、盘子、玩具或瓶盖)具有透光的特性,加以利用可以用来创建照明解决方案。在城市的街头巷尾,经常可以看到居民楼外悬挂的晾衣绳和路边小店门口摆放的塑料盆,这些旧的或是废弃的彩色塑料制品在日常生活中几乎随处可见,日晒、风化及刮痕增加了利用光线对它们进行色彩实验的机会。塑料制品上的划痕以及生活留下的印记并不一定都是不利因素,对它们的这些特征进行重新审视,是对废弃物品再利用与再设计的思考和洞见。

照明设计的创作本质上是关于灯光的控制,以及光线呈现出的效果。在广州制作的Firesticks吊灯是由来自服装制造业废弃的彩色塑料线轴制成。当这些廉价且平淡无奇的单个线轴被作为灯具组件进行重新定义及群组后,呈现出了具有活力的形式美感。每一个组件由两个不同造型的线轴插入组合而成,吊灯内部使用的是LED灯泡照明,灯光可以轻易地透过这些廉价塑料产生柔和的色彩与光晕变化。"Blue Suspended"是由数百个蓝色的废弃塑料枝杈做成的环形吊灯。枝杈用透明的绳线相连并由一条LED光带贯穿,散发出的光晕强烈且色彩浓烈。另外两组作品是用废塑料枝杈缠绕成的球形吊灯,枝杈不规则地排列缠绕,光源从交纵错杂的核心渗透至外缘,在缠绕的结构中穿插,强调了形体的复杂性。

支持单位: 广州市低碳产业协会、广州市华鲁达集团
有限公司、英国驻华大使馆文化教育处
赞助商: PAK lighting PR China
设计师: 戴维·布莱姆斯通
Supported by Guangzhou Low Carbon Industries
Association, Guangzhou Valuda Group Co. Ltd
and British Council China
Sponsored by PAK lighting PR China
Designed by Dave Bramston

Ms. Kitty light

Firesticks

Firewands (100 lights collection)
Guangzhou, PR China 2014

Blue Suspended (左下)
Mines (右)
Red Knot (右下)

Daisy Cutter Thunder

9 Experimental Play—Illumination Solutions

Understanding the character of materials through experimentation and play can provide insight for potential directions and outcomes. The diffusion of light through cheap, translucent plastic products such as a bowl, a plate, a toy or a bottle cap is a characteristic that can be exploited in the creation of various lighting solutions. In downtown, China it is not uncommon to see washing lines shrouding the outside of community tower blocks or plastic basins outside public and private buildings lining the streets. These items are often sun-bleached due to being continuously exposed to sunlight. Abandoned, colored plastic is simple to source, and in situations where such items are weathered or distressed, the opportunity for experimentation with light is enhanced. Scratches or a series of marks to plastic products do not need to be seen as a detrimental feature but rather an insight into the item's former use and might even suggest a particular direction to adopt.

The creation of a lighting design is fundamentally about the control of light and what the designer is able to make the light achieve. The Guangzhou Firestick Chandelier is constructed from used colored plastic spools sourced from the fashion industry. These abandoned, innocuous, and perhaps seemingly banal components manage to adopt a vibrant and vivid presence when their alluring beauty is collectively defined in a single composition. Firesticks exploit the subdued colors in cheap plastics to create a vibrant chandelier when illuminated from within by a single LED bulb. The arrangements are created by pushing together abandoned thread spools. Blue Suspended is created using hundreds of blue-colored waste plastic branches looped and threaded onto a disused airline. Knitted between the individual branches is a continual LED strip that creates an intense glow as it emerges. Mines and Red Knot are single bulbs surrounded by waste plastic branches in an irregular arrangement. Interconnected branches create a central density where the core light source is located. The light emanating from within the tangled structure emphasizes the complexity of the form.

小技巧:
 重复构造具有相似特征的物品比单个物品更具视觉冲击力。Firewands使用了"重复"设计手法,一系列螺纹线轴通过简单的附件推入连接,其中的LED光源则强化了塑料原有的颜色。

Tips:
 The repeated use of identical objects or items with similar characteristics can create an outcome with greater impact than a single item illuminated on its own. A range of different thread spools is connected through simple push-fit attachments. LED strips within the various firewands exaggerate the colorings.

参与活动与协同创新

从实验游戏中对色彩基本原理的探索开始,"色彩创意"在致敬包豪斯艺术家和设计师原创精神的同时,旨在找寻创新的色彩交流与表达方式,不断尝试在实践活动与协同创新中掌握色彩与创意之间的生成关系。

原创路径对设计师和创新来说极其重要,与不同领域的人交流合作是我们在创新过程中使用的重要方法——超越自己熟知的界线、学科间的交叉与融合、不同知识领域间碰撞而产生灵感。IDEO设计公司掌门人蒂姆·布朗就曾提出,设计师是具有T型知识结构的创新型人才。广阔的视野与专业的纵深发展使我们的学生不仅能胜任某一专业领域的工作,同样可以适应周围复杂环境变化所带来的挑战。

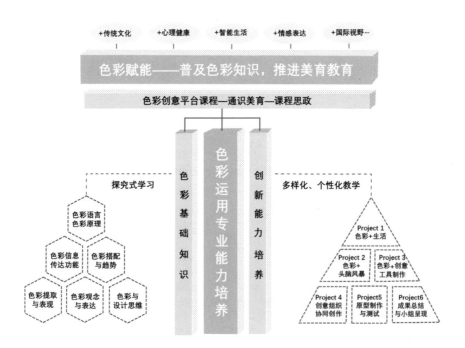

Engaging Activity & Co-design

Starting from 9 Inspiring Experimental Plays that have explored the color theory based on the Experimental Play of Color. The color creation practice aims to build on the original thinking of the Bauhaus artists and designers whilst intentionally also embracing alternative processes and exploring multiple color relationships in engaging activity and co-design.

It is increasingly important to a search to identify original paths for the designer to venture beyond what they know and gain an understanding of other disciplines through collaborating with those with specialist knowledge. Tim Brown at IDEO refers to designers needing to adopt a T bar approach to design, a situation where they are competent in a particular field but are also aware of their surroundings.

创新创业思维培养的5个技巧:
1) 团队合作、学习风格和领导力。
2) 通过回顾、讨论和执行活动, 将创业特质带入日常生活。
3) 让学生有机会评估和展示个人的创业技能与计划, 并通过问题意识、创造性思维、批判性思维、工作坊等方式开发与培养技能。
4) 理解和不断探索创新创业思维, 并尽可能地在实践中加以运用。
5) 运用跨学科研究方法和项目管理技能, 创新或改良现有的设计。

5-Tips for Growing with An The Entrepreneurial Mindset:
1) Team-working, learning styles and leadership.
2) Reviews, discuss and perform activities to bring entrepreneurial characteristics to life.
3) Give students the opportunity to evaluate and demonstrate their personal entrepreneurial skills and plans to grow through the development of skills such as problem-solving, creative and critical thinking skills and processes, exercises and seminars.
4) Define and explore entrepreneurial mindsets and skills and practice them in various situations.
5) Develop new and enhance existing design, research and project management skills appropriate to interdisciplinary.

◼ 向孩子们学习

❝ 一个孩子可以教给成年人三件事:无缘无故的快乐,忙碌与专注,以及知道该如何全力追求自己想要的东西.
　　　　　　　　　　　　——保罗·科埃略 ❞

　　在前面介绍的实验游戏1和2中,我们发现孩子们更容易融入游戏的氛围,在愉快的探索中即可完成任务。孩童时代往往才是创造力的旺盛时期,有着色彩设计和实践经验的成人有时还不如孩子们的创作来得那么轻松自由。在英国国家手工艺与设计中心,4岁的孩子可以运用游戏式的色彩工具独立完成印记任务的创作,效果时而出乎我们的意料。这类项目也被推广应用到由美智联合(中国)组织的儿童设计思维教学实验项目中。

　　合作创新旨在激发团队的创造性与活力,与孩子们一起的系列活动为我们带来了许多灵感,例如去除颜色的创作,去色的过程与往常的色彩混合正好相反,是通过使用漂白剂或清洁剂去除织物上的颜色来实现的。

　　"英国国家艺术设计星期六俱乐部于1999年由英国索雷尔基金会成立,旨在为14–17岁的年轻创新者们提供了一个激发创意的平台。"

图片中的Lucy Coney是英国国家艺术设计星期六俱乐部的成员,她将装有颜料的容器在自己的身体周围移动,在纸面留下了移动的轨迹。

IMG: Lucy Coney, National Art & Design Saturday Club, moves a large container around herself to create a series of marks on paper.

Learn from Children

A child can teach an adult three things: to be happy for no reason, to always be busy with something, and to know how to demand with all his might that which he de sires.

— *Paulo Coelho*

The freedom of the mark-making process made it relatively difficult between an outcome created by a creative individual with experience and color awareness compared to an individual that was simply engaged in experimental play #1 and #2. The approach to creating artwork on a large scale had been developed to instigate group activities to explore color. However, at the National Centre for Craft & Design UK, young children aged 4 years old were able to adopt the process and began to generate unexpected artworks on an individual basis. The development of the experimental play project also involved the Art & More art club in Xuzhou PR China during later development.

The activity at the National Centre for Craft & Design UK prompted the idea of creating works through the removal of color. The process was explored through the use of bleach that removed the color from fabric. The process also instigated other thoughts, such as the potential to create works with liquid clay.

' The National Art & Design Saturday Club was founded in the UK by the Sorrell Foundation in 1999. The National Art & Design Saturday Club provides an inspirational platform for young creatives aged between 14-17 years old.'

◼ 街头时尚项目

　　街头时尚项目深入中、英社区与街道和当地居民共同创作和设计。该系列活动重视环境的可持续发展和对废弃物品的再利用,过程中融合创业理念并鼓励营销活动,项目的持续目标是发展协同创新和创业教育。

> *人们对活动的反应令人振奋。当我们再次被邀请回到中国,在其他社区开展更多的街头时尚项目时,我们还联合了英国林肯郡的当地政府,在林肯市继续推进这一项目。*
>
> ——戴维·布莱姆斯通

◼ 刘村的WHITE GARAGE

　　2016年,戴维和韩国设计师Mi Young Jang到访广州刘村进行调研和项目实践。这个为期三天的项目吸引了150多名村民的参与,他们不仅参与了布料的印制,由当地裁缝店缝制成服装,而且自己还作为模特在街头进行了服装的展示。居民对WHITE GARAGE项目的热情,促使了该活动与很多社区和街道进行合作,并且利用废弃的车门、围栏和熨衣板等物品继续创新对布料纹样的制作方式。

IMG: Street printing
Location: Guangzhou

Street Fashion Collections

The aim of the Street Fashion Project is to bring communities together, to value waste materials, and to develop local entrepreneurs for local distribution. The on-going aim of the project is to develop collaborative innovation and entrepreneurship education.

The response was unexpected and inspiring. When we were invited back to China to conduct more street fashion projects in other Chinese villages, we decided it would also be good to replicate the concept in Lincoln with the aim of bringing our own communities together.

—*Dave Bramston*

WHITE GARAGE in Liu Village

In 2016 David and South Korean designer Mi Young Jang visited Liu village in Guangzhou and initiated printing with found objects in the community. The three-day project in the Chinese village attracted more than 150 residents and involved them in printing, making and modeling their work. Fabrics printed by residents on the street of Liu Village are made up into garments for residents to model in the street fashion show by local workers on the street with sewing machines. White Garage now engages with diverse communities to develop localized apparel on the street using an array of abandoned objects, including car doors, fencing and ironing boards.

IMG from Emily Norton
Location: Lincoln UK

■ Sincil Bank的街头时尚项目

　　中国矿业大学的色彩创意项目进一步
改进了刘村WHITE GARAGE活动中色彩的
制作方法和实践方式,并尝试在英国继续推
进此类活动。其中一项是在英国林肯市Sincil
Bank街区的街头进行,邀请了当地居民共同
参与。活动最后还由林肯市政府组织街区居
民参观了展览和时装秀,参与印制布料活动
的居民还可以为他们的作品命名。通过街头
时尚项目的开展,或许有机会将中国和英国
的社区联系起来。

IMG: Fashion collection created by Bai Xue (School of Art, Architecture & Design, University of Lincoln UK, 2015)

■ 案例解析

　　大量的印刷品和实验探索也为时装
设计等其他的专业方向带来设计灵感。作
为色彩创意多维探索的成果之一,以下作
品是白雪创作的时装系列(英国林肯大学
艺术、建筑与设计学院,2015)。

■ Street Fashion in Sincil Bank

Since the 2016 street fashion show in Liu village, the project has continued to develop in Lincoln and through the CUMT Color Creation project, which has engaged in other creative color methods and practice. In the UK, the project was developed in Sincil Bank Lincoln and again conducted on the street to bring diverse communities together. Lincoln (UK) city council invited all residents in Sincil Bank to the show. Anyone who prints a fabric will be able to name that specific print for future reference. Eventually there may be an opportunity to connect the Chinese and England communities with an international street fashion show.

■ Case Study

The broad range of prints and experimental work conducted created opportunities for other disciplines including fashion. Outputs from the experimental play are intended to influence other disciplines.

□ Jelly: Street Fashion

团队在林肯大学的工作成果引起了英国国家手工艺与设计中心（NCCD）的兴趣。2018年，团队在NCCD举办了色彩创意教学与创作成果展，并由戴维、叶莉和设计团队在设计中心内进行了为期两周的Jelly：Street Fashion开放式工作坊，共同创作的成果也以社区时装秀的方式进行展现。合作活动包括：

- 街头时尚版画家庭工作坊
- 社区时装秀
- 展览

● 创业实践活动

合作伙伴的加入为色彩创意的项目进程以及方法的改进提供了驱动力，他们中不仅有个人的创新探索，也有英国星期六俱乐部里的年轻创作者们、清华大学美术学院国际预科班的学生们，以及林肯大学艺术、建筑与设计学院MAIDE工作室的研究生们的共同协作与努力。另外，手工艺和传统染色技艺的加入不仅丰富了色彩创意的方式方法，也进一步推进了色彩理论在中国教育领域的传播。色彩创意教学始终反

☐ Jelly: Street Fashion

The outputs from the works conducted in Lincoln attracted the interest of the National Centre for Craft & Design UK. In 2018, Jelly: Street Fashion was exhibited at NCCD. Dave Bramston, Yeli and a team of designers conducted a two-week offering free drop-in workshops for visitors to participate in what will culminate in a final community fashion show.
- Street Fashion Print Making Family Workshops
- Community Fashion Show
- Exhibition

Broker Experimental

The processes and techniques that were being developed through the process of color creation projects had involved a variety of creative individuals. They also had included the young creatives of the National Art & Design Saturday Club, creative designers at FATU International Foundation Course program and postgraduate students in MAIDE studios at the Lincoln School of Art, Architecture & Design. The exploration has also referenced

对单一的绘制训练，而是期望团队协作带来的灵感碰撞，以及合作与跨界下所激发的创新意识。

　　色彩创意提供了比传统绘画练习更为丰富的多样形式，不断地鼓励在更广泛的领域讨论设计实践。例如在各种日常生活用品中的应用，如口罩、包、雨伞、围巾、服饰等。色彩创意在每个阶段的探索也都在为下一步的创新与再设计提供平台，它正在演变为多种创新创业的实践方式。这种实验、探索、合作的方式鼓励的是积极进取的心态，也在引导着我们去理解如何运用简单的方式将色彩与创意进行系列的成果转化。

Photography: Sigrid G Jordhoy
Models: Dong Wei – Lincoln UK

FATU Tsinghua University Beijing
Models: Wang Yixuan – Beijing CN

活动支持：
中国矿业大学建筑与设计学院
英国林肯大学
清华美院留学班FATU
广州工程技术职业学院
林肯市政府
林肯郡政府
英国彩票艺术基金会
广州市低碳行业协会
北京、徐州、广州和林肯市的居民

many traditional techniques and practices that engage communities and groups of individuals rather than isolated, repetitive practices conducted on an individual basis.

The Color Creation practice applied the outcomes to masks, bags, umbrellas, scarves, clothing and a variety of other wares. The practice had been given the opportunity to go further than a series of painting exercises conducted by an individual. It had evolved into a variety of practices with each stage informing a further step and instigating further questions. The approach encouraged a pro-active mentality and led to an understanding of how a simple process related to color could be readily transformed into a series of desirable outputs.

Supported by
School of Architecture & Design CUMT Xuzhou China
University of Lincoln UK
FATU Tsinghua University Beijing
Guangdong Institute of Technology Guangzhou China
Lincoln City Council
Lincolnshire County Council
Lottery UK Funding Arts for All
Guangzhou Low Carbon Industries Association
Residents of Beijing, Xuzhou, Guangzhou & Lincoln

结语

Embrace color like never before!
让我们前所未有地拥抱色彩！

目光所及之处皆有色彩，它带给了我们灵感、欣喜与挑战。色彩是任何一种设计都需要的基本设计元素，它们传达信息、创造情感，也在激发着设计创意。色彩的那些通感与意蕴一直在影响着我们的思考与判断；在不同文化与生活背景下，那些色彩隐喻意义间的差异会成为我们个人经历中的独特记忆，也是重要的视觉图式与信息符号。色彩帮助我们区分和识别生活环境中的事物、唤起我们的记忆、影响我们的行为，它是艺术和设计、营销与生产的重要组成部分。色彩创意教学项目的设置或是学习工具的游戏化方式都在使色彩学习的过程变得更为简单、高效且学以致用。感谢所有支持该项目并提供资料与图像的设计师、艺术家、摄影师和研究人员。

虽然设计过程需要独立的思考，但当今设计问题的多样性和复杂性更需要我们从整体层面看待问题，即使有专家和大师的指导，设计进程的推进也需要团队的共同努力，需要多学科的交叉和协同创新。色彩创意通过类似于孟菲斯集团那种勇于突破的当代实践精神，探讨了伊顿及包豪斯教学中的色彩理论。此外，该方法也在向那些具有创新精神的当代艺术家和设计师们致敬，学习他们的环保意识、对废弃材料的再利用以及在作品中展现出的色彩与质感的活力。

Conclusion

Everywhere we look, there's color, color, and more color—they are packed with challenges, inspires and delights. Color is considered the important factor of any kind of design, and it can convey messages, create emotions, generate interest. Color has deep subliminal meanings that affect our thinking and rationality. They have symbolic meaning that changes amongst different cultures and countries. Color is a familiar and important feature of our experience of the world that helps us to distinguish and identify things in our environment. Color is an essential part of art and design, marketing and production. The on-going aim of the color creation courses and study material makes the learning process straightforward and memorable, leading to improved quality of work and job satisfaction.

Isolation in the design process may be needed to think for a short time, but questions should be looked at in unison rather than a single individual looking to go it alone. Almost without exception, the design process is a team effort even if there is a recognized maestro steering the process. The Color Creation explores the theory of Itten and the introductory color theory program at the Bauhaus but through a contemporary process that is akin to the Memphis Group practice and theory. In addition, the approach aimed to emulate influential contemporary artists and designers, for example, the environmental awareness, application of waste materials, the color and tactile vibrancy seen in works.

色彩术语表
Color Terminology Glossary

Achromatic

无彩色——是不带彩度的一系列中性白色、灰色或黑色，几乎只有明度差别，没有色调和饱和度的特征。

Chroma / Chromaticness

色度——与饱和度相关，是颜色或色相的另一种表示。色度是孟塞尔色彩系统中色彩属性的一种，用于表示与同一灰度值的偏离程度。

Color Space

色彩空间——由三个基色（红/绿/蓝）和白色的CIE1931色度坐标组成，包括色相（X轴）/明度（Z轴）/饱和度（Y轴），便于正确解释和显示颜色，使观察者能够一致地评估色差。

Color Temperature

色温——是一种温度衡量方法，使用这种方法标定的色温与普通大众所认为的"暖"和"冷"正好相反，颜色随着色温的升高而变蓝，而随着色温的降低而变红，即红色的色温最低，而蓝色是最高的色温。

Gamut

色域——描述的是由技术系统、设备、程序能够产生的色彩格式，是属于一个色彩空间的所有颜色的集合。色域范围就是色彩表达强韧、柔弱、温暖、寒冷等概念信息的色彩"语法"。不同媒体的色域应小于人眼可检测的色域。

Lightness, Value, Brightness, Luminance

明度/亮度/照度——是色彩的固有属性，也指颜色的明暗程度，通过与中性灰度进行比较将其进行分类。

Pigment

颜料——是赋予一定颜色的原料，绘画中统称为颜料。颜料可以由多种成分组成，包括矿物质、天然/人工染料、合成化合物等。除色彩外，颜料还可以提供其他特性，如不透明度、硬度、耐久性。

Pixel

像素——是分辨率的单位，是"图片元素"的缩写。在印刷中，像素是由几种颜料的沉积叠加而成；在屏幕上的任何位置由三个磷光点构成：红、绿、蓝，它们的相对强度不同产生了所需的颜色外观。

Spectrum

光谱——是复色光经过色散系统（如棱镜、光栅）分光后，按波长（或频率）的大小依次排列有序的连续颜色，也称为色谱。

LRV

光反射率值——Light Reflectance Valueis的缩写，使用分光光度计进行的仪器测量，它等效于CIE Y，是表面反射的可见光所占的比例，对人眼对光的敏感度进行加权。

CIELab / Lab / L*a*b*

Lab色彩空间——是一种对立色标的色彩空间，将色彩位于三维直角坐标系中，三个维度分别是亮度（L*），红色/绿色（a*）和黄色/蓝色（b*）。CIELab是一个系统，结合三个独立的变量，基于三对对立的颜色视觉:白−黑/红−绿/黄−蓝来定义总色差，也被称为L*a*b*。

ISO

国际标准化组织——International Standards Organisation的缩写。

Pantone

潘通色彩——是一种色彩交流的国际标准语言。潘通的匹配系统色彩指南(PMS)，解决有关在制图行业制造精确色彩配比的问题，以及帮助品牌或产品的色彩选择做出决策。

Munsell Color

孟塞尔色彩——继承于Albert H. Munsell，致力于帮助人们轻松、准确地传达颜色。孟塞尔色彩为人们提供了基于孟塞尔色彩理论的有效色彩工具、技巧和技术。

CIE

国际照明委员会——色彩测量机构，是Commission Internationale d'Eclairage的缩写。

NCS

自然色彩系统——Natural Color System的缩写，是基于人类感知颜色的方式建立的色彩服务和教育系统，可以帮助定义、设计、传达色彩。

RAL Color

劳尔(RAL)色彩标准——用于定义油漆、涂料、塑料等的标准色彩信息。德国劳尔(RAL)是历史悠久的色彩研究机构，拥有着最受欢迎的欧洲色彩标准。

致谢

本书所呈现的色彩创意研究绝非个人之力所能及，而是有赖于教学团队的精诚合作。除了本书的作者外，我们的团队成员还包括林裕熙老师、赵潇老师，刘群山老师。感谢美国设计学习网络的学者和教育家桃丽丝·韦尔斯·帕帕内克女士，她通过在线讲座和网络评图的方式为我们的课程作出贡献。

还要感谢多个设计教学活动对本书的支持，其中包括中国矿业大学建筑与设计学院的色彩创意课程，英国林肯大学的国际设计硕士项目，湖北美术学院的工业设计课程，清华大学的工业设计课程和国际预科课程，美国费城大学的工业设计课程，中国美术学院的国际预科课程，广州工程技术职业学院的设计课程，英国索雷尔基金会国家艺术与设计星期六俱乐部，以及英国国家手工艺与设计中心的工作坊。

不知不觉中，这项研究已历经数年，本书的写作历程伴随着色彩创意课程项目的建设和发展，涉及多个团体和个人。在这期间还要特别感谢参与到这个教学项目中学习的学生们，他们对色彩和创意的热情与活力是我们坚持设计研究永不枯竭的动力源。

Acknowledgements

Thank you to all the designers, artists, photographers and researchers who have supported this project and provided exciting images and statements. The work presented in this book could never have been done without the close collaboration of a group of dedicated colleagues. Besides the three authors, they are LinYuxi, Zhaoxiao, LiuQunshan. We are grateful to scholar and educator Doris Wells-Pappanek of Design Learning Network the US, who contributed to the project through delivering online guest lectures and attending final reviews.

Many thanks also to the programs where design workshops supported the research for the book, including the Color Creation program at the Chinese University of Mining and Technology School of Arts & Design, Xuzhou, China, the MA International Design Enterprise program at the University of Lincoln UK, the Industrial Design program at Hubei Institute of Fine Arts, Wuhan, China, the Industrial Design program and the international foundation program at Tsinghua University, Beijing, China, the industrial design program at Philadelphia University, USA, the international foundation course students at the China Academy of Fine Arts (CAFA IFC), Beijing, China, the design programs at the Guangzhou Institute of Technology, Guangzhou, China, the Sorrell Foundation National Art & Design Saturday Club (UK), and the National Centre for Craft & Design UK.

Unknowingly, the research began decades before, on multiple levels and by many individuals. The writing of this book has been as long a journey as the project itself. Special thanks to those students who have gone through the program in the past years. Their passion and curiosity for color and creation have always been the primary motivity behind this design study.

作者简介
About the Author

叶莉　设计师、设计研究与教育工作者,中国矿业大学建筑与设计学院副教授,硕士生导师,致力于视觉传达设计及教育方法研究。作为"色彩创意"教学团队的负责人,以多元方式组织设计教学中的色彩创意生成与创新实践活动,定期与欧、美教育机构共同组织设计教学研讨会,在中国和欧洲策划了多个有影响力的展览与学术活动。曾撰写*Idea Searching for Design*一书,由英国伦敦Bloomsbury出版社出版。

戴维·布莱姆斯通　英国设计师、教育工作者与作家,美国工业设计师协会会员和导师,主持英国索雷尔基金会"国家艺术与设计星期六俱乐部"林肯区项目,曾任英国林肯大学艺术设计方向本科生和研究生课程负责人。戴维创建了Bramston设计工作室,从事可持续设计研究工作,与美国、欧洲和东亚地区保持着长期的设计合作,还致力于促进中、英间的教学与文化交流活动,出版多部设计类专著。

刘一玉　美术与设计教育工作者,中国矿业大学建筑与设计学院环境设计系讲师,从事色彩相关教学工作多年,致力于色彩知识体系的理论研究与实践探索,将其中的审美经验与文化智慧应用于设计教学,在传统色彩与现代设计之间找寻传承与超越,使更多的学生以及设计人员关注色彩在当代生活中的作用。

Ye Li is a designer, researcher and design educator in China. An association Professor at the School of Architecture and Design, China University of Mining & Technology (CUMT), Yeli leads the art and design learning program by exploring many different methods to visual information communication and interaction, and is one author of the Previous book Idea Searching for Design published by Bloomsbury in London. As a leader of the Color Creation practice and research, Yeli explores many different methods to communicate color practice, is proactive in supporting the activities of many British and American design educational institutions and makes regular visits to the UK to attend design workshops and conduct design research. She has worked on, and led, many prestigious live projects throughout China and Europe.

Dave Bramston is a designer, author and educator based in the UK and working predominantly between the UK and China to create environmentally design aware works using waste materials. A former leader of undergraduate and postgraduate programs in the UK, Dave is now the Director of the Bramston studio. Dave is also the founder of the National Art & Design Saturday Club within the School of Art & Design, coordinated by the Sorrell Foundation, London, UK. Dave has presented designs and worked with companies in the US, Europe and the Far East, is the author of several design books and is an international member and mentor of the Industrial Designers Society of America (IDSA).

Liu Yiyu as an educator of art and design, is a lecturer in the Environmental Design Department of the School of Architecture and Design, China University of Mining & Technology (CUMT). She has been dedicated to color teaching for years. Committing herself to theoretical research and practical application of color knowledge system, she applies aesthetic experience and cultural wisdom in daily design teaching and identifies inheritance and transcendence from traditional color and modern design. These efforts enable more students and designers to recognize the role of color in today's life.

图书在版编目（CIP）数据

色彩创意——像设计师一样思考色彩 = Color
Creation:Think about Color As a Designer:汉英对照 /
叶莉，（英）戴维·布莱姆斯通，刘一玉著 .—北京：中
国建筑工业出版社，2020. 11
　　ISBN 978-7-112-25633-4

　　Ⅰ．①色… Ⅱ．①叶… ②戴… ③刘… Ⅲ．①色彩－
设计－高等学校－教材－汉、英 Ⅳ．① J063

中国版本图书馆 CIP 数据核字（2020）第 240455 号

责任编辑：唐　旭　贺　伟
责任校对：焦　乐

色彩创意　像设计师一样思考色彩
Color Creation　Think about Color As a Designer
叶莉　[英]戴维·布莱姆斯通　刘一玉　著
＊
中国建筑工业出版社出版、发行（北京海淀三里河路9号）
各地新华书店、建筑书店经销
天津图文方嘉印刷有限公司印刷
＊
开本：880 毫米×1230 毫米　1/32　印张：6　字数：217 千字
2020年11月第一版　2020年11月第一次印刷
定价：**58.00** 元（配有数字资源）
ISBN 978-7-112-25633-4
　　　　（36631）